IMAGES
of America

CHARRO DAYS IN BROWNSVILLE

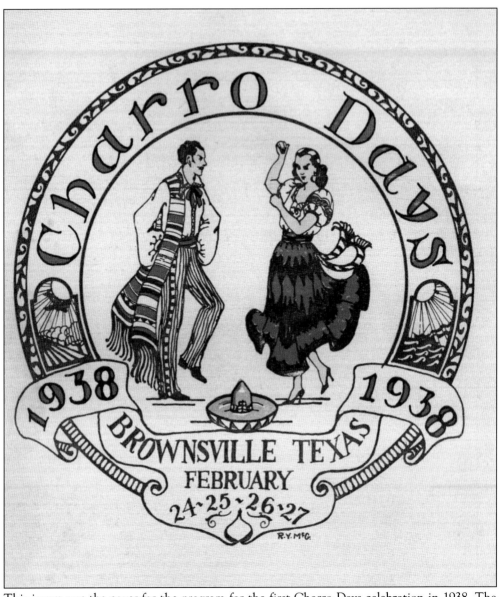

This image was the cover for the program for the first Charro Days celebration in 1938. The dancers portrayed in the center appear to be performing the *jarabe tapatio* (Mexican hat dance). Designed especially for tourists, the program provided information on Mexican customs and local points of interest as well as advertisements by area businesses. (Courtesy of Brownsville Historical Association [BHA].)

ON THE COVER: The first Charro Days in 1938 was dependent on the original horsepower as well as automobiles for transportation during the three parades. In this photograph, a wagonload of festively clad youngsters slowly passes a portion of the huge crowd that turned out on Levee Street. (Courtesy of BHA.)

IMAGES
of America

CHARRO DAYS IN BROWNSVILLE

Anthony Knopp, Manuel Medrano,
Priscilla Rodriguez, and
the Brownsville Historical Association

ARCADIA
PUBLISHING

Published by Arcadia Publishing
Charleston, South Carolina

Printed in the United States of America

Library of Congress Control Number: 2009927144

For all general information contact Arcadia Publishing at:
Telephone 843-853-2070
Fax 843-853-0044
E-mail sales@arcadiapublishing.com
For customer service and orders:
Toll-Free 1-888-313-2665

Visit us on the Internet at www.arcadiapublishing.com

*To the founders of Charro Days, all their successors, and the
community they celebrate for its heritage, culture, and friendship.*

CONTENTS

ACKNOWLEDGMENTS

For affection, inspiration, and support, we thank Eric Schreiber; Chavela, Estevan, Daniel, and Noe Medrano; and Alma Ortiz Knopp. For their essential aid on the project, we are grateful to Angie Morales and the staff of the history department office at the University of Texas at Brownsville (UTB) and Texas Southmost College (TSC); Al Tapia and Juan Miguel Gonzalez of UTB/TSC Media Service; UTB/TSC students Monica Lerma, Ana Villalpando, Myrna de Coss, Crystal Cole, and Tonantzin Juarez; Tylene Lesvesque, Javier Garcia, and all of the staff at the Brownsville Heritage Museum; and Eric Schreiber for editing and Alma Ortiz Knopp for scanning and extensive computer work.

This book began as a project of the Brownsville Historical Association (BHA), and we appreciate the support of the board of directors of the BHA. We join them in their dedication to history education by committing all author royalties from the sale of this book to a scholarship fund to benefit history students at UTB/TSC.

We received donations of photographs and other materials from many sources, too many to thank by name, and are very grateful for their contributions. We need to express particular gratitude to those who made substantial contributions: Chula Griffin, Antonio N. Zavaleta, Danny Loff, Bob and Rachel Torres, Elia Garcia Cruz, Magda Garza, Ruben Garcia, Harry McNair, Alfonso Barrientos, Sammy Herrera, and Drue Brown.

Finally, we offer an appreciative thank-you to Arcadia Publishing editors Kristie Kelly and Hannah Carney for their guidance and encouragement.

Many of the images in this volume appear courtesy of the Brownsville Historical Association (BHA) and the Brownsville Independent School District (BISD). The University of Texas at Brownsville and Texas Southmost College is abbreviated as UTB/TSC.

INTRODUCTION

"With a history as big as Texas!"—such is the claim of the Brownsville Convention and Visitors Bureau for the city. The first battles of the 19th-century war with Mexico were fought outside the future city. Brownsville was founded as a result of the 1846 war and the establishment of the border at the Rio Grande. Brownsville's Mexican sister city, Matamoros, had already begun life around the time of the American Revolution. Both cities shared the experience of a period of frontier violence and civil war in the late 1850s and the 1860s. After an era of stagnation, the development of railroads and irrigation at the beginning of the 20th century enabled an economic boom in agriculture that lasted half a century. Disruptions occurred during the Mexican Revolution and World War I and, of course, during the economic collapse of the 1930s.

Despite the difficulties of life on the border, the populations had grown significantly. By 1930, Brownsville had 22,000 inhabitants, largely thanks to an influx of Mexicans escaping the violence and hardship of the revolution and Midwestern Anglos (Caucasians) seeking agricultural land. Enhanced cultural awareness was inevitable, though often at a superficial level. The preeminence of Mexican culture and customs was apparent but less so on the upper reaches of Brownsville society, populated by both Mexican Americans and Anglos. Nevertheless, the knowledge of Mexican culture and customs would prove fortuitous.

Back in 1937, Brownsville civic leaders were still trying to cope with the continuing ills of the Great Depression, and a civic celebration offered an opportunity to both lift spirits and attract tourists and dollars to aid economic recovery. The inspiration had come from a successful Citrus Festival at the other end of the Rio Grande Valley and the celebration accompanying the opening of the Port of Brownsville the previous year. An idea conceived by local businessman Kenneth Faxon was promoted by a group on the Pan American Roundtable. They persuaded the Brownsville Chamber of Commerce to organize a fiesta committee and plan a pre-Lenten celebration for February 24–27 in 1938. Charro Days was born and continues today as the annual celebration by Brownsville, Texas, of its Mexican heritage as exemplified by the Charro—a fancy-dress Mexican version of the rodeo cowboy.

Faxon, long acknowledged as the "father" of Charro Days, headed the committee. A glance at the program for the first fiesta reveals an exceptionally ambitious plan for four days of fun beginning with fireworks on Thursday evening and ending with a *Noche Mexicana* across the border in Matamoros on Sunday night. In between were three parades, street dances, and a grand ball; motor and sail boat races; a bullfight and a rodeo; and a concert by the *Banda de Artilleria*, all the way from Mexico City. A unique feature of the first and all succeeding Charro Days was the *grito* (yell). This tradition was begun by A. A. "Daddy" Hargrove, who gave a free-form shout of joy to begin the celebration. Hargrove gave the grito for many years and served one year as president. Kenneth Faxon observed, "We have probably made some mistakes, but thanks to the spontaneous enthusiasm and wholehearted cooperation not only of the people of Brownsville, but the people of Matamoros and the entire Valley as well, we have succeeded in doing much more than we had hoped for in our first year."

Kenneth Faxon served as president of Charro Days for the next two years and again several years later, and remained on the committee for decades. The format for the first fiesta had been so successful that modifications were incremental. More and more folks were able to wear Mexican costumes, and beard-growing was mandatory. Smooth-cheeked males were "arrested" and hauled before the "brush court." Some floats in the parades were horse-drawn, and 5¢ would buy an oxcart ride through downtown. Almost taken for granted was the participation of military units and the band from Fort Brown. Soldiers paraded in authentic Civil War uniforms of Union and Confederacy dragoons.

From the very first, the Charro Days fiesta was able to capture the fascination of national and international audiences. *National Geographic* covered the first celebration, and the following year, moviegoers across the nation saw Charro Days scenes in Paramount and Universal newsreels. Macy's Latin Fair in New York featured a Charro Days theme in 1942. *Time* and *Life* magazines printed spreads on the border fiesta. All three radio networks broadcast the balls coast-to-coast, while the Voice of America and the Armed Services Network carried Charro Days events worldwide. In 1952, two networks telecast the main parade.

Children have always been an important part of the Charro Days events. The first celebration had a "Kids Parade," costumed dance reviews at the high school, and a carnival. Over the years, participation in the children's parade reached 12,000. Members of the Pan American Roundtable taught and demonstrated costumes and dances for the children. Soon the Fiesta de los Niños provided a venue for students to demonstrate folkloric dances learned in the schools.

Brownsville's sister city of Matamoros continued to play an important role as a partner in Brownsville's commemoration of its Mexican culture. Floats, charros, and school groups from Matamoros participated in the earliest parades, and the International Parade crossed the border. Artillery and cavalry bands from Mexico City continued to perform in concerts and parades. *Noche Mexicana* and bullfights continued across the Rio Grande, and in 1950, the Fiesta Parade crossed the river for the first time to entertain Matamoros crowds. By 1954, the international bridges were open for everyone to cross during Charro Days. In 1958, Gov. Norberto Trevino Zapata of Tamaulipas joined Texas governor Price Daniel for the celebration. Governor Daniel later proclaimed Charro Days "a major contribution to the Good Neighbor Policy, benefiting all peoples in the western hemisphere."

A major challenge during the early years was posed by the coming of World War II. Wartime restrictions and rationing resulted in replacing the Grand Parade with a special Charro roundup. Many events focused on the military or provided free admission for "the boys in uniform." The 1945 events included a mock bombing of Tokyo at the athletic field. In 1946, the return of parades with floats also saw a visit from war hero Gen. Jonathan Wainwright.

The World War II era was also the big band era, and some of the biggest came to Brownsville to perform at Charro Days *bailes* and balls after the war. The earliest dances were held on the patio at the El Jardin Hotel, then during the war at the Fort Brown Officers Club and the Aransas Compress. After the war, the Fort Brown Motor Pool was remodeled and served as the site of dances until the civic center was constructed in the mid-1950s. The "big name" bands began to arrive just after World War II—Xavier Cugat, the rumba "King" in 1946 and Desi Arnaz of *Babaloo* fame in 1947, a few years before the *I Love Lucy* show hit television.

The big bands continued to arrive in the 1950s, including Skinny Ennis, Tex Beneke, Les Elgart, Ralph Martiere, Jimmy Dorsey, and Freddy Martin and his Coconut Grove Orchestra. Parades were the main attraction. Often there were seven during the 1950s celebrations, with as many as 50,000 in attendance at the main parade. Parades and floats crossed between Brownsville and Matamoros, and were televised by two major networks. In 1960, Texas's largest newspaper ran a full-color photo layout on the parades and celebration.

In the early 1960s, chamber of commerce leaders sought new opportunities to establish closer relations with Mexico. The chamber decided to honor a Mexican citizen who had significantly contributed "to U.S.–Mexico friendship." The honorees would be known as "Mr. Amigo." The first Mr. Amigo was ex-president Miguel Aleman in 1964, followed by Cantinflas, Mexico's

greatest movie star, in 1965. In 1969, the Mr. Amigo Association decided to schedule its event in conjunction with Charro Days, of which it has been a part ever since. Beginning in the 1970s, the Mr. Amigos were selected from the entertainment field because they attracted more attention and larger crowds.

During the 1970s and early 1980s, it seemed to some as though Charro Days had become too formalized and scripted. Returning resident Danny Loff noted few people in charro dress and no activities for the general population. Loff resolved to remedy this situation by creating the Sombrero Festival "to enhance the spirit of Charro Days" in 1986. Usually conducted at Washington Park, the Sombrero Festival offers musical performances, food booths, displays, and contests for jalapeño-eating, *gritos*, and the frijolympics. Attendance reaches 40,000.

Those who have known Charro Days over the decades are fond of pointing out that whenever there has been a slackening of interest, something has developed to revitalize the activities. If history is any guide, Sombrero Fest is only the most recent development in the evolution of Charro Days, and locals can anticipate additional changes as the event adapts to the needs of the 21st century. For the last few years, "Amigoland Fiesta Internacional" has provided free entertainment, primarily border and Tejano bands, across the street from the Charro Days carnival. Whether this unofficial, for-profit operation will become part of Charro Days remains to be seen.

The story of Charro Days is one of the cultural preservation and transmission in an atmosphere of celebration and sharing. Despite the stress and strain inevitable in producing an annual event of such magnitude, cordiality and goodwill have been the hallmarks of the Brownsville fiesta. The Charro Days spirit endures and contributes to the growth of civic pride and community spirit.

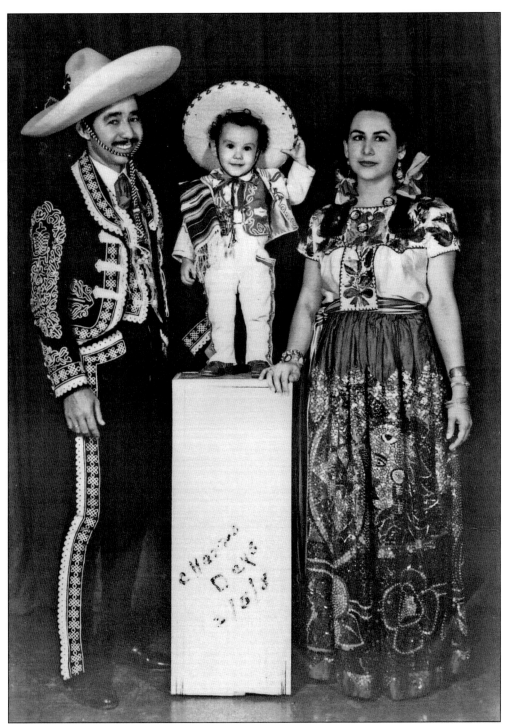

Romeo Villarreal Yzaguirre and his wife, Paulita Villarreal Lozano, stand with their son, Romeo Villarreal Jr., who seems ready to tip his sombrero to the viewers. Although Charro Days attire has not changed dramatically over the years, the Villarreal family's costumes show the influence of the style of the era in this 1948 photograph. (Courtesy of Juliet V. Garcia.)

One

The Founding of Charro Days

The Depression of the 1930s created economic adversity in every community in the United States, and despite the economic stimulus provided by the recent construction and opening of the Port of Brownsville, the border city experienced much the same economic hardship as other communities. In 1937, local businessman Kenneth Faxon worked with the Pan American Roundtable, a women's organization dedicated to cultural understanding and preservation, to develop and host a local fiesta. The original plan called for a one-day event to attract visitors and take locals' minds off of the tough economic times. However, the chamber of commerce joined in the plan, and the fiesta grew into a four-day international pre-Lenten celebration. J. M. Stein, editor of the Brownsville *Herald*, then suggested the name Charro Days, and a cultural institution was born.

The Charro Days founders had little experience in international festivals and even less time to prepare for the first Charro Days. Despite this, Charro Days opened in February 1938 with parades, dances, fireworks, a carnival, a rodeo, and motorboat races. These events and their successors were heavily promoted through both advertising and the wooing of reporters to obtain favorable coverage. The investment paid off in widespread publicity and a steady increase in tourism.

Some of the early Charro Days activities are now only memories. The speedboat regatta was conducted at the port turning basin and attracted competitive racers from far and wide, but it was phased out after only a few years. The rodeo lacked crowd consistency and was gradually transformed into a Mexican-style rodeo, the *charreada*, a more appropriate event for Charro Days. Street dances on closed streets downtown were popular with those who could not afford the private invitation dances, but alcohol and misbehavior prompted police to urge their termination. The bullfights in Matamoros ended when the *Plaza de Toros* burned down in 1967.

Of course, the evolution of Charro Days activities was inevitable, and the disappearance of some features was compensated by the development of new activities. It has proven difficult, however, to recapture the spirit of the inaugural celebration and its early years.

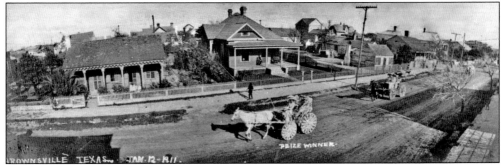

Brownsville began hosting winter celebrations in 1904 when the railroad began to bring visitors to the city. The first formal event was called the Winter Fair, and it occurred in 1908. In 1911, contestants competed for prizes in the flower parade, which had entrants moving through the unpaved streets of that era. Unfortunately, the social upheaval caused by the Mexican Revolution and World War I temporarily disrupted the events. (Courtesy of BHA.)

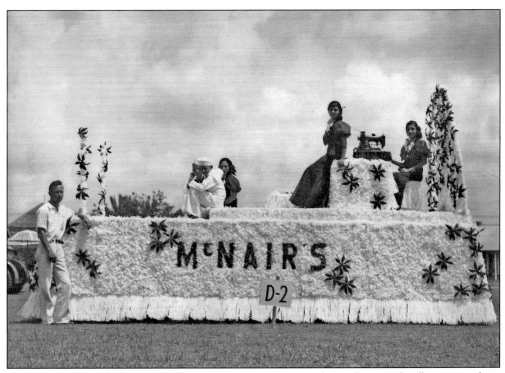

In 1936, McNair Clothing Manufacturing Company entered this float in the flower parade, a pre-Lenten celebration. The woman on top of the float with a sewing machine demonstrates the services of the business. This unique way of promoting one's business with a float was a tradition that carried on in later Charro Days celebrations. (Courtesy of the McNair family.)

Kenneth Faxon was the founder of Charro Days and served four times as the president of the fiesta's board of directors. He is shown with Bernice Wilson. Faxon chronicled the history of Charro Days, but the inspiration for it goes further back. In 1832, merchants from Matamoros, Brownsville's sister city, heard about American settlers in Texas, so they loaded up their wares and dressed in their traditional costumes to visit and do business. The groups then met and shared the first bicultural celebration on record. Although only 75 to 100 merchants participated in the first event, they planted the seeds for the modern celebration of Charro Days. (Courtesy of Bob and Rachel Torres.)

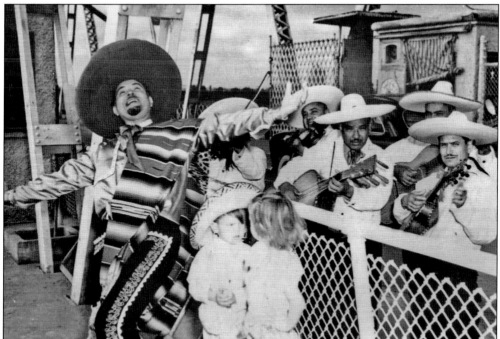

This iconic photograph shows A. A. "Daddy" Hargrove giving the *grito*. The *grito* is a free-form shout of joy with a Mexican twist, and it became a Charro Days tradition early on. Eventually the *grito* took its place as the inaugural event of the celebration. Daddy Hargrove served on the Charro Days Board of Directors from its inception and for many years afterward, and he was always available for the *grito*. (Courtesy of BHA.)

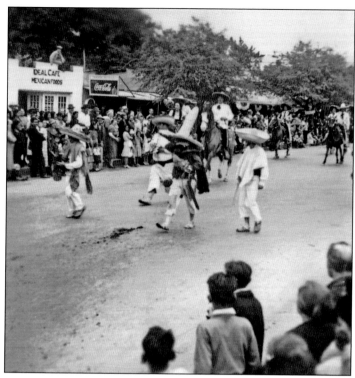

The first Charro Days parade featured men dressed in charro outfits, women dressed as chinas poblanas (traditional female companions of charros), horse-drawn floats, and street dancing. Initially, the Charro Days parade was led down Levee Street and up Elizabeth Street. The photograph to the left shows the parade on Elizabeth Street, and the photograph below shows costumed parade participants on Levee Street. The Traveler's Hotel is shown in the background. (Photographs by Les Mauldin; both, courtesy of BHA.)

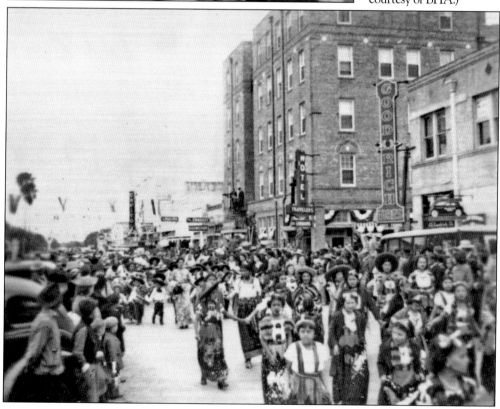

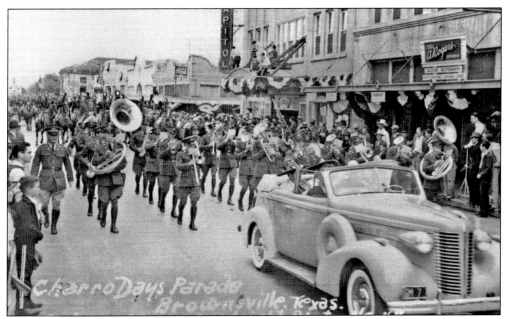

Music was essential to the Charro Days parades, and beginning in 1938, the Fort Brown garrison helped provide it. The band of the 12th Cavalry, under the direction of WO Wilfred T. Archambeault, led the military contingent, followed by mounted units wearing uniforms of the U.S.–Mexico war era. At that time, the cavalry band was considered Brownsville's community band. (Courtesy of BHA.)

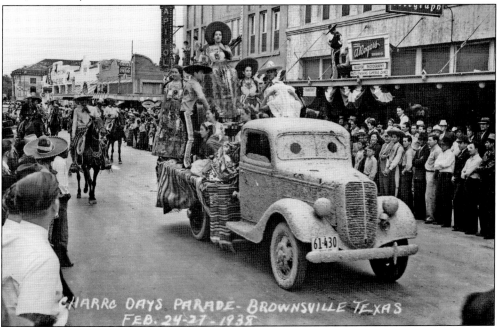

The Charro Days organization expressed its gratitude to Tipton Motors and other local automobile dealerships for supplying the trucks without which the first parades could not have been conducted. Many of the trucks were decorated and flocked in an attempt to disguise their basic appearance and to provide a float-like ambiance. The one pictured here is topped by local ladies in costume. (Courtesy of BHA.)

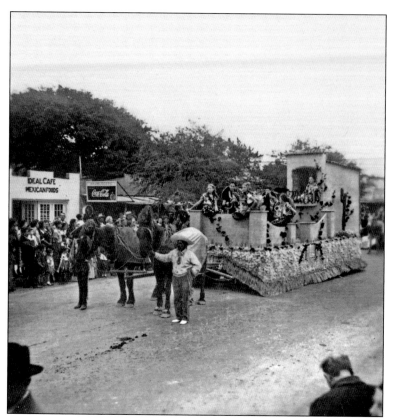

This float presents the traditional Mexican balcony scene from which a *señorita* was serenaded by a musically inclined suitor. Many of the floats in early Charro Days parades reflected a romanticized image of Mexico. This float was one of the early horse-drawn floats. (Courtesy of BHA.)

For many decades, most Brownsville residents received their water from *piperos*, who filled huge barrels from the Rio Grande and pulled them through the streets to sell by the bucket. By the start of Charro Days, *piperos* had all but disappeared, so this wagon was a recreation of a *pipero* vehicle with a youthful charro leaning against the water barrel. (Photograph by Les Mauldin; courtesy of BHA.)

Folkloric dances have been a part of Charro Days from the earliest years. The famous "Mexican Hat Dance" was re-created for this early postcard. Formulaic Mexican imagery played an important role in efforts to attract *gringo* tourists during the early years when little was known about the customs and culture of northern Mexico. (Courtesy of BHA.)

Although animal power was no longer essential for transportation, it provided a touch of rural Mexico for the early Charro Days celebrations. The cart-riders in this postcard wear the mandatory beards that were required for all male participants. Violators would be hauled before a "brush court" and fined for their negligence. (Courtesy of BHA.)

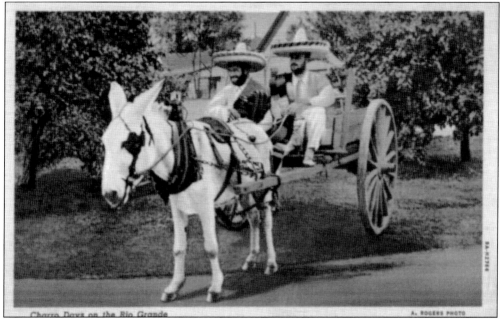

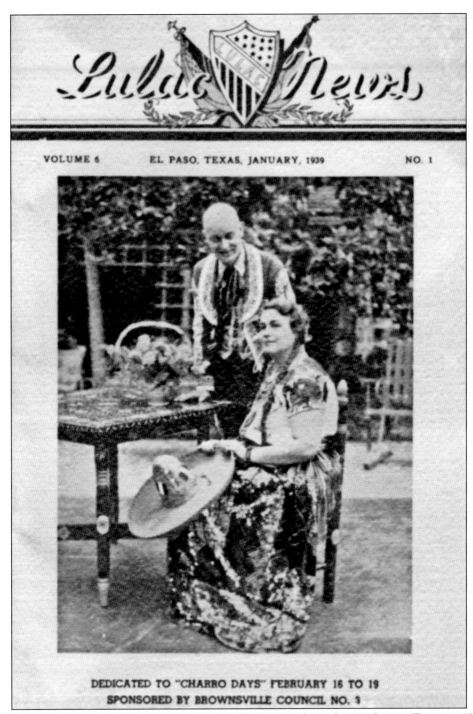

Lulac News

VOLUME 6 EL PASO, TEXAS, JANUARY, 1939 NO. 1

DEDICATED TO "CHARRO DAYS" FEBRUARY 16 TO 19
SPONSORED BY BROWNSVILLE COUNCIL NO. 1

The League of United Latin American Citizens (Lulac) was formed in Harlingen, Texas, in 1927 and soon became the most influential Mexican-American organization in the United States. Lulac's *News* devoted much of its first 1939 issue to photographs and stories about Charro Days, including this cover. Numerous local merchants purchased advertisements in this issue to promote their businesses as well as Charro Days. (Courtesy of BHA.)

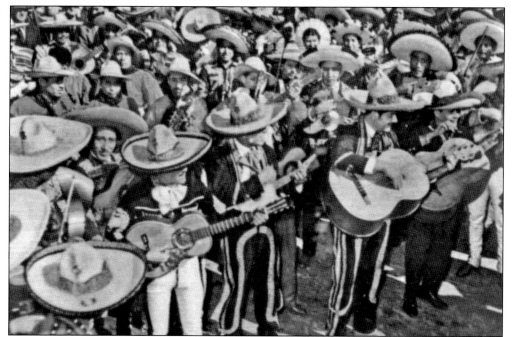

This photograph depicts massed musicians performing *mariachi*-style tunes during a Charro Days street celebration. The different costumes indicate they are all from distinct musical organizations. A mariachi group usually consists of at least three violins, two trumpets, one Mexican guitar, one *vihuela* (a high-pitched five-string guitar), a *guitarron* (a small acoustic bass), and occasionally a harp. The dress for a *mariachi* usually consists of silver-studded charro outfits with wide-brimmed hats. (Courtesy of BHA.)

The first Charro Days parade featured a variety of floats. This one shows women dressed as chinas poblanas in a military vehicle from Fort Brown. During this time, the troopers stationed at Fort Brown from 1929 to 1945 included the 124th Cavalry Regiment, Texas National Guard, which became one of the last mounted cavalry regiments in the U.S. Army. (Courtesy of BHA.)

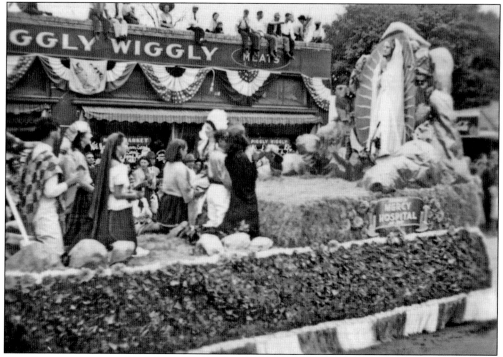

This float was sponsored by Mercy Hospital, which opened in 1928. The facility was operated by the Sisters of Mercy on land donated by the Stillman family, descendants of Brownsville's founder, Charles Stillman. As a Catholic organization, it is not surprising to see Our Lady of Guadalupe represented on the float. In the background, parade watchers are gathered on the roof of the Piggly Wiggly grocery store. (Photograph by Les Mauldin; courtesy of BHA.)

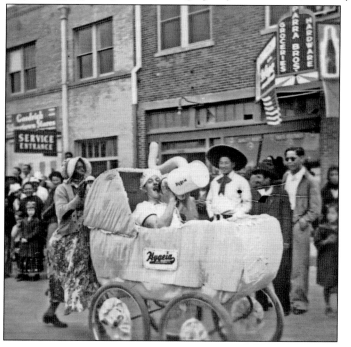

This photograph shows a small float sponsored by the Hygeia Dairy Company. While some of the more traditional floats depicted people in Mexican costumes, this float captures the fun and playfulness of early Charro Days celebrations. In the background, one can see the Parra Brothers Grocery Store. (Photograph by Les Mauldin; courtesy of BHA.)

This float from the first Charro Days parade features costumed paraders and a *jacal*, which is Spanish for hut. In South Texas, the thatched roofs were often made of grass or palm leaves. The rectangular-shaped dwelling was often a permanent home for the poor, but the more wealthy occupants viewed them as temporary homes until a better house could be built. (Photograph by Les Mauldin; courtesy of BHA.)

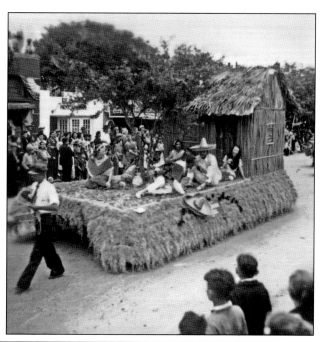

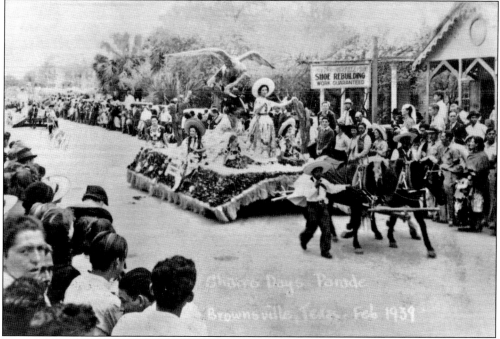

The eagle and serpent symbol has appeared frequently during Charro Days, as well it should, being the national symbol of Mexico. According to legend, the hummingbird-warrior god of the Aztecs guided his people to their eventual home at Tenochtitlan (Mexico City). *Huitzilopochtli* told them to search for an eagle atop a cactus eating a serpent—here they would establish their homeland. The symbol appears on the Mexican flag. A horse-drawn float during a 1939 parade displays a large eagle and serpent plus a bevy of lovely ladies, and an elaborate charro jacket displays the symbol as well. (Courtesy of BHA.)

Yacht Club Regatta

SAILBOAT RACES
SATURDAY, FEBRUARY 26, 2:00 P. M.

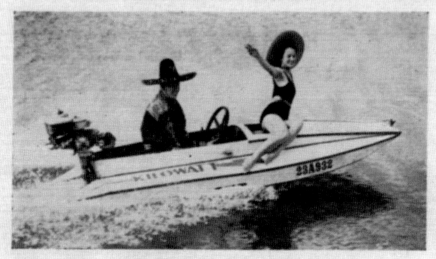

MOTORBOAT RACES
SUNDAY, FEBRUARY 27, 1:30 P. M.

The first Charro Days program included this promotional photograph (above) for the speedboat "regatta" at the turning basin for the new Port of Brownsville. While attendees might be attracted for the sport of the races themselves, clearly the organizers believed that the image of an attractive woman in a swimsuit might enhance the appeal of the event. The slim-lined speedboats (below) were reminiscent of the cigarette boats used to smuggle liquor during Prohibition. Racers came from other states and Mexico just to participate in this event. (Both, courtesy of BHA.)

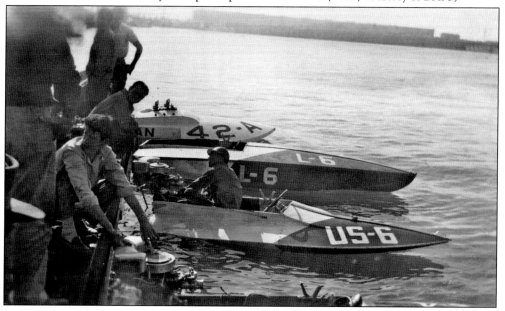

The first Charro Days celebration included a rodeo that drew large crowds. The rodeo was eventually replaced by the *charreada*, a Mexican-style rodeo. This first rodeo drew a large crowd, but subsequent rodeos had less attendance and contributed to its demise. The Church of the Advent, a Spanish Colonial Revival–style building completed in 1927, is seen in the background. It still stands today on Elizabeth Street. (Photograph by Les Mauldin; courtesy of BHA.)

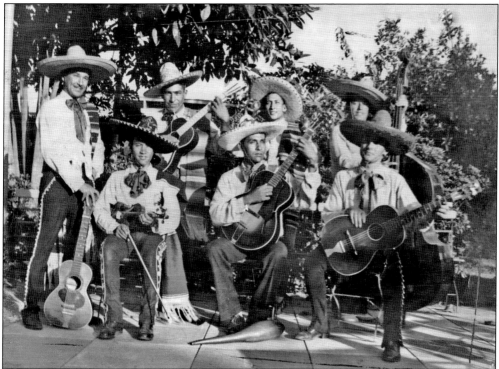

A significant feature of early Charro Days was the street dances held in downtown Brownsville. The dances featured local musicians such as those shown in this photograph. The street dances were a way for people of modest means to attend Charro Days celebrations. Those of higher incomes attended private dances held in private homes or in various locations throughout the city, including at Fort Brown. (Courtesy of BHA).

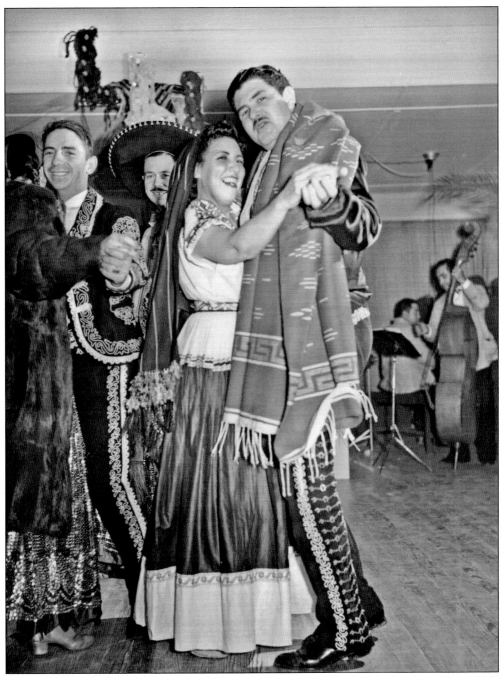

One of the groups that made the initial Charro Days so successful was the Triple-L Club, which stood for Live, Love, and Laugh Club. This club was composed of prominent Mexican American residents of Brownsville. These photographs show dancers performing at a Triple-L dance in the early years of the festival. (Photograph by Arthur Rothstein; courtesy of the Library of Congress.)

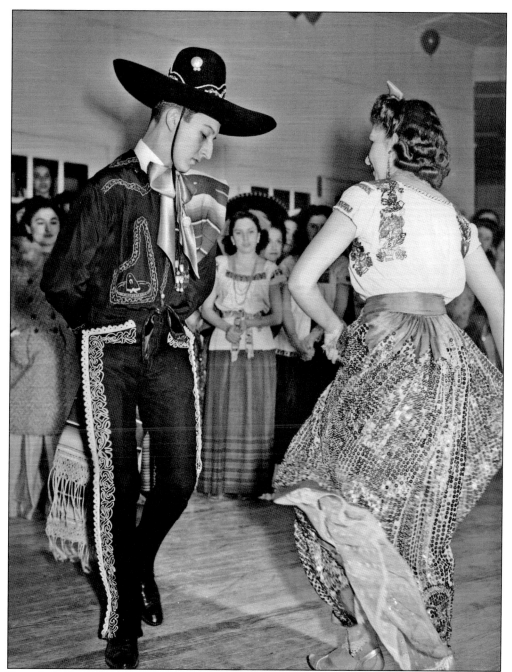

Famed photographer Arthur Rothstein photographed the 1942 Charro Days events, including the Triple-L Club dance. There was no really appropriate location for such dances in that era, so the club used the Aransas cotton compress or the Fort Brown Motor Pool building. The dancing couples seemed untroubled by the location. (Photograph by Arthur Rothstein; courtesy of the Library of Congress.)

La China Poblana

THE name of the colorful native costume worn by the fun-loving Mexican girls is a story in itself. Legend tells that a beautiful Chinese princess, sold as a slave to a handsome Mexican rancher, created the unique dress. Beloved by the people of Puebla, while she lived, she was honored when she died by the wearing of the costume which she designed.

The true *China Poblana* consists of a wide skirt, usually red or white and green, and white blouse embroidered about the square neck and the shoulders with gorgeous flowers or Indian designs. The thousands of rainbow-colored sequins sewed in intricate designs of *El Charro* and *La China* dancing the *Jarabe Tapatio*, a Mexican eagle, wings outspread, with a snake in its mouth—symbol of victory over wickedness, the detailed Aztec calendar, or flowers, catch the light and reflect it a hundredfold. A *rebozo*, scarf, is worn carelessly across the shoulders. A gay, vari-colored ribbon tied about her hair emphasizes the snapping black eyes of the coquettish *senorita*.

E

mat
his
mar
ing
felt
and
of
emb
in i
talo
et a
mor
shir
coin
sleev
shou
colo
be u
cool
over
hou
deci
cou
pref
the
and
is th
oftt
pear
sidel
fully
a me
lant

harro

truly the Mexican
rtorial elegance is a
ide with him, and
ne sometimes costs
pesos. His crown-
sombrero of finest
ilver braided brim
rap. On the back
rtable shirt is an
an eagle, holding
and gripping in its
d spear. His jack-
trousers are even
broidered than his
ntations of silver
ttons down the
egs. Over his left
y thrown a many
ine, soft wool, to
overing against the
when he is riding
le during the late
blanket should he
ng the way. The
ly of his choice is
of serenades, and
to his beautiful
worded love-songs
beribboned guitar,
th mother - of -
k, flashing eyes,
triguing and care-
ache. Truly he is
llow, and his gal-

The official 1940 program for Charro Days included a description of the standard costumes for the festival, the charro for men and the china poblana for women. These descriptions were useful not only to tourists unfamiliar with Mexican customs, but also to local inhabitants only vaguely aware of aspects of the culture. The wearing of such costumes was prevalent during the early years at street dances and parades. (Courtesy of BHA.)

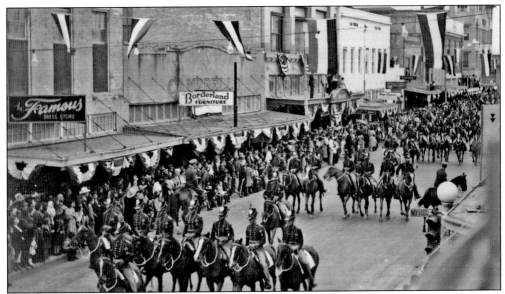

Dragoons were mounted infantry who were an important factor in the early battles of the U.S.–Mexico war fought near Brownsville in 1846. Their role in establishing a U.S. military presence on the Rio Grande was honored in the 1938 Charro Days parades by the 12th Cavalry troops from Fort Brown, who rode in replica dragoon uniforms of the Mexican War era. (Courtesy of BHA.)

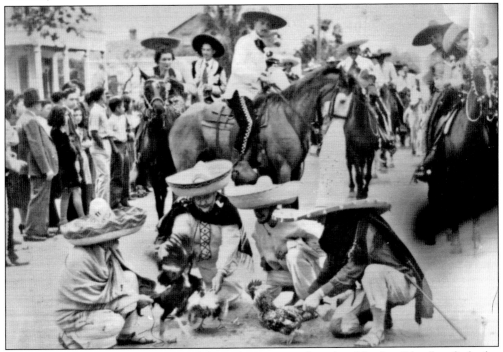

A colorful but controversial feature of the early years was the role of the *bandidos* (bandits) who staged cockfights in the midst of the parades and depicted heavy-drinking stereotypes of Mexican bandits. Despite the popularity of the *bandidos* with tourists, concern for Mexican sensitivities led to a name change in 1943, when *bandidos* became "rebels." (Courtesy of BHA.)

Wiley Truss, one of the founders of the *bandidos*, is pictured here with the costume worn by the *bandidos*. The gang would stage "hold-ups" for play money and brandish weapons during the parades, pulling girls aside from the crowd to dance. (Courtesy of Chula Griffin.)

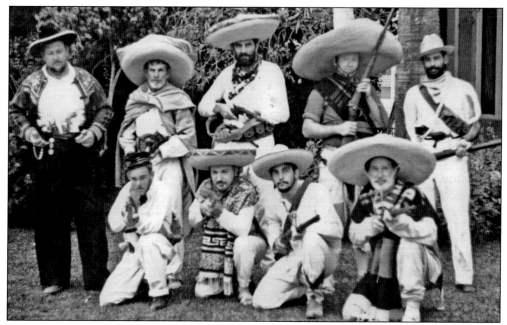

These *bandidos* are dressed in peasant garb and are brandishing their weapons at the photographer. Pictured from left to right are (first row) Jimmy Truss, unidentified, Ernest "Ernie" Hacker, and Cuban Monsees; (second row) George Leonard, Wiley Truss, "Lefty" Appleton, Kenneth "Red" Clark, and Charlie Bracht. (Courtesy of Chula Griffin.)

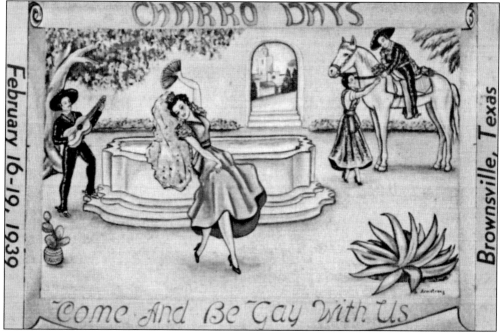

The second Charro Days celebration inspired this idealized image of Mexican life in a postcard. The slogan of the early years, "Come and Be Gay with Us," while no longer appropriate, conveyed the original spirit of a joyous mood. The slogan appeared on much of the promotional material and on the program. (Courtesy of BHA.)

This float in an early Charro Days parade depicts a huge sombrero and paraders dressed in traditional garb. The sombrero is one of the popular images of Charro Days. This float is sponsored by the Gateway Bridge Company, which built the Gateway International Bridge that leads into Matamoros from Brownsville in 1928. (Photograph by Les Mauldin; courtesy of BHA.)

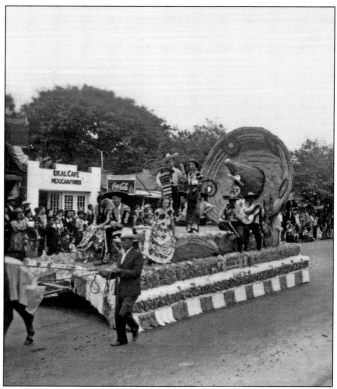

The first Charro Days dances were held on the patio of El Jardin Hotel. This spot added a Latin flavor to the colorful costume balls. The women depicted here are dressed in a variety of Mexican costumes, particularly the china poblana. El Jardin Hotel was the unofficial headquarters for Charro Days activities in the early years. It was also often a popular location for dances, weddings, and fiestas. (Photograph by Les Mauldin; courtesy of BHA.)

A well-known tourist haunt at the outskirts of Mexico City was, and remains, the "floating gardens" of Xochimilco. This float from one of the first Charro Days re-creates one of the boats that plied the waterways bearing the tourists. As seen here, Xochimilco boats were named for the wives or *novias* (girlfriends) of the boat operator; the names were spelled out in flowers. (Photograph by Les Mauldin; courtesy of BHA.)

Pan-American Costumes

One of the most interesting features of Charro Days will be the costumes worn by the members of the Pan-American Round T a b l e. Each member's costume will depict the festive dress in all the elaborate details of s o m e Central or South American country. T h e Gaucho's wife of the Argentine will vie with the gay colors of Peru and Nicaragua. If there is any shade of color or combinations of colors that you have not seen before you will see it during Charro Days.

Under the palms in the exotic Lower R:o Rio Grande Valley.

The program for the first Charro Days included this acknowledgment of the role of the ladies of the Pan American Roundtable, who used the folkloric costumes of American nations to foster international knowledge and understanding. Every year, the Pan American Roundtable performs a style show of their costumes as part of Charro Days. (Courtesy of BHA.)

Two

FIESTAS MEXICANAS IN MATAMOROS

From the very beginning of Charro Days, Matamoros has been an active partner in the Brownsville celebration while conducting similar activities south of the Rio Grande. In fact, Matamoros claims a precedent by virtue of the Carnaval de Matamoros in 1936 with the "burning" of bad feelings and the coronation of the "ugly" king, as well as a beauteous queen.

In the 1940 Charro Days program, Sunday was "Matamoros Day," with a *charreada* (stylized Mexican rodeo) and coronation, a bullfight, and the *Noche Mexicana* at the Plaza Hidalgo in the evening. Ten years later, Matamoros's involvement reached a new level when Matamoros students were invited to join the Grand Charro Days Parade. Some 800 Mexican students and at least five Matamoros floats helped make the parade a truly international event. For many years, Matamoros provided *Así Es Mi Tierra*, a production of songs, folk dances, and music by the State Band of Tamaulipas at Tucker Field by the Brownsville High School.

For many years beginning in the early 1950s, the bridges across the Rio Grande were "open" for all to cross without restriction during Charro Days. Events began with the "Grito" and "Hands Across the Bridge," as citizens and officials of both cities joined hands across the river and flowers of friendship were tossed into the water. Illegal immigration and security issues ended the open bridge practice, but the other events at the bridge have continued.

The Matamoros aspect of Charro Days has evolved and undergone several name changes. In 1970, the name Fiestas Mexicanas was adopted and has endured. Matamoros began to invite its own celebrities in 1979—an *Invitado de Honor* or *Valor Nacional*. These special guests included such Mexican luminaries as hometown star Rigo Tovar, Paquita la del Barrio, and Lalo Gonzalez ("Piporro"). Fiestas Mexicanas has its own parades and performances, presided over by the *Rey Feo* (ugly king) and various queens.

Matamoros historian Rosaura Alicia Davila summed up the fraternal relationship: "Both Charro Days and Fiestas Mexicanas represent the opportunity for two peoples to entertain themselves together, sharing traditions, and the resulting tourism represents an economic boost for the region."

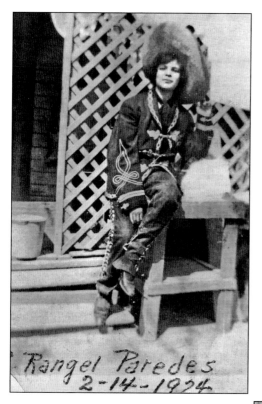

María Guadalupe Rangel married Eliseo Paredes Manzano, Matamoros's foremost historian. In this February 1924 photograph, she models a traditional male charro outfit, perhaps dressed for one of the pre-Lenten *carnavales* that predated the creation of Charro Days. The oversize outfit was probably not a permanent part of her wardrobe. (Courtesy of Blanca Treviño.)

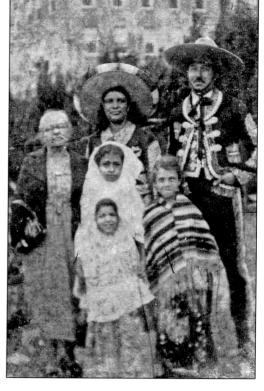

All dressed up for an early Charro Days are the members of the Eliseo Paredes Manzano family, including his mother, Cleotilde; his wife, Guadalupe; and daughters Blanca, Graciela, and Isaura. Eliseo was one of Matamoros's most prominent citizens, serving as the first *Cronista* (official historian) of the city. He was also the founder of the historical association of Matamoros and was the first director of the Casamata historical museum. (Courtesy of Blanca Treviño.)

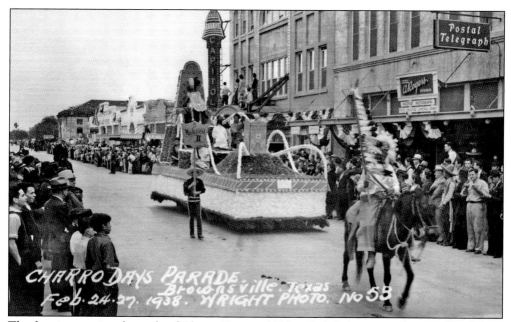

The first international parade of Charro Days in 1938 included this *carro alegorico* (float) from Matamoros. The float bears the Aztec emperor Moctezuma II and his court, doomed to defeat by Hernán Cortéz. The backdrop represents an Aztec temple. The float was passing the Capitol movie theater on Levee Street. (Courtesy of Charro Days, Inc.)

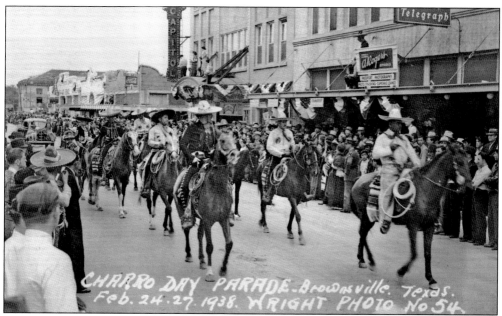

How could it be Charro Days without charros? Although Brownsville held a cowboy rodeo, Matamoros provided the namesake for the event as charros under wide-brimmed *sombreros* paraded through the street of both cities in 1938. The Brownsville rodeo soon transformed into a *charreada*. In recent times, there were several charro associations in Matamoros. (Courtesy of Charro Days, Inc.)

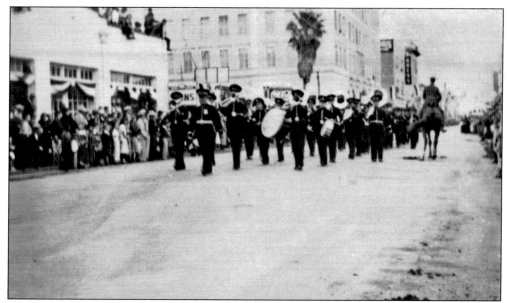

The first Charro Days scored a real coup when Matamoros officials arranged to bring one of the top Mexican military bands, the Banda Artillería (Artillery Band), all the way from Mexico City to perform in the parades. The impression created by the band was so favorable that they were invited to succeeding Charro Days and were added to the Mexican aspect of the events. (Courtesy of BHA.)

Famed American photographer Arthur Rothstein captured for posterity two Matamoros entries in the 1942 International Parade. Two girls display the banner "*Escuelas de Matamoros*" (Matamoros Schools) before the first entry, while the Colegio Mexico drum-and-bugle corps followed on. The border was no obstacle to paraders and visitors of both nations in the early years. (Photograph by Arthur Rothstein; courtesy of Library of Congress.)

This handsome couple from Matamoros performed an "Argentine Tango" at the Dittman Theater on February 15, 1941. Eleazar "Rudy" Paredes and Ida Orson performed as part of the Charro Days celebration that year. Adolph Dittman operated a movie theater in downtown Brownsville for many years beginning during the Mexican Revolution. (Courtesy of Blanca Treviño.)

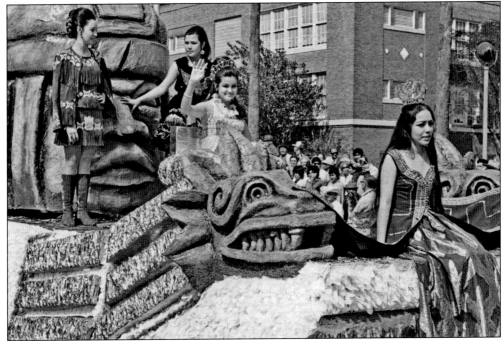

Matamoros contributed several floats, known as *carros alegoricos*, to the international Charro Days parades. The parades usually began by the high school in Brownsville, crossed Gateway Bridge to Matamoros, then followed Obregón and Sexta Streets to the Plaza Hidalgo, passing in front of the *presidencia* (city hall). The floats often displayed Mexican historical themes, as was the case in the photograph above. The float displays representations of Quetzalcoatl, the feathered serpent god of the Aztecs (and others) and one of the giant Olmec heads from Villahermosa. The float below curiously offers a winged lion with a human head, often known as a sphinx and dating from antiquity. (Both, courtesy of Bob and Rachel Torres.)

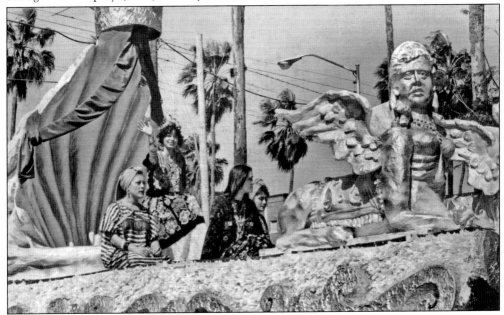

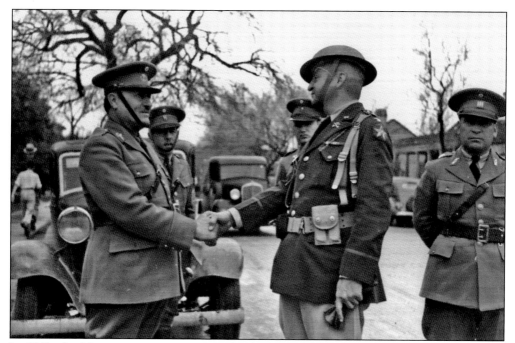

In 1942, the Mexican garrison commander from Matamoros (left) and his staff joined the commanding officer of Fort Brown (in helmet) in a show of goodwill during Charro Days. The United States and Mexico were in the process of becoming allies in World War II, but Mexico did not declare war until May. Mexican airforce flyers underwent some training in Brownsville during the war. (Photograph by Arthur Rothstein; courtesy of Library of Congress.)

The military aspect of World War II is evidenced in this float as it passes bystanders on a Matamoros street. The fully uniformed miniature soldiers strike distinct poses, but one little fellow is either lying down on the job or pretending to be shot. Patriotic and military themes prevailed throughout the war years. (Courtesy of Dalyn Ruiz.)

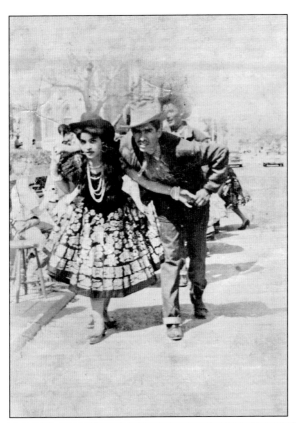

In 1961, Eufemia Flores and Joel García Cruz prepared for the pre-Lenten festival by rehearsing and performing a dance entitled *Corrido de Monterrey*, one of a variety of Fiestas Mexicanas activities. At the time, they were students at the Escuela Normal J. Guadalupe Mainero, a teacher preparation school in Matamoros. (Courtesy of Joel Garcia Cruz.)

"Piporro" (Eulalio Gonzalez) is at the wheel of an antique auto in a festival parade. He was a "distinguished guest" of Fiestas Mexicanas in the 1990s. Piporro was one of Mexico's favorite movie stars over several decades. He was well known for his roles as a comedian and singer. (Courtesy of Clemente Rendon.)

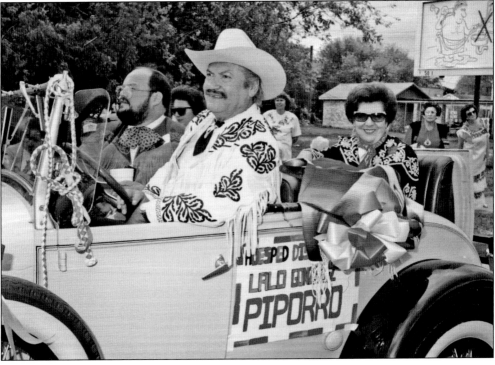

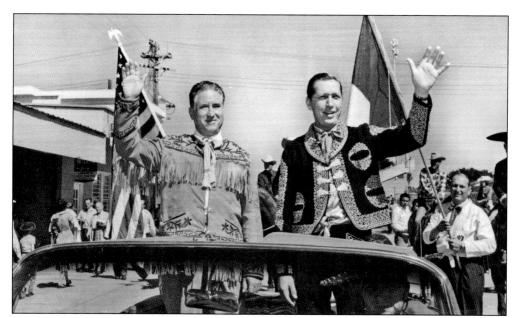

In 1962, Matamoros mayor Virgilio Garza Ruiz (left) joined Brownsville mayor Dr. Jake George for a ride in a convertible in the International Parade. It became a tradition for the mayors of both cities to meet at the Gateway Bridge at the beginning of Charro Days and Fiestas Mexicanas for a "Hands Across the Bridge" ceremony of friendship between the two cities. (Courtesy of Bob and Rachel Torres.)

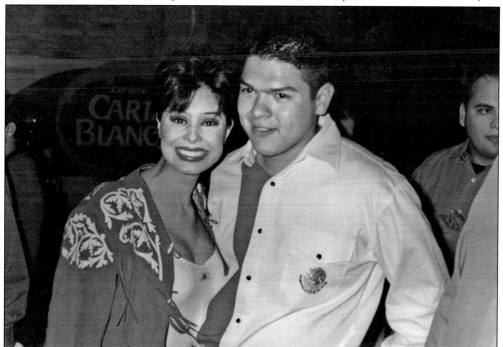

Lizandro García enthusiastically poses with Yadira Carillo, a companion of Mr. Amigo and a popular Mexican *novela* (soap opera) actress. Mexican entertainers have been especially important to Fiestas Mexicanas, as in the case of this event at the Casamata Museum. García later married Vanessa Lartigue, a Fiestas Mexicanas queen. (Courtesy of Lizandro Garcia.)

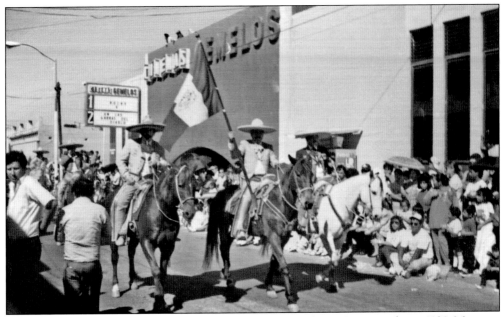

Mounted charros from Matamoros participated in the first Charro Days parades in 1938. Mexican actor/comedian Cantinflas persuaded the *Asociación de Charros* of Mexico City to send a contingent of experts to Matamoros's aid in organizing and giving more relevance to the charro aspect of the fiestas. In this photograph, charros parade down Sixth Street past the old movie theater in Matamoros. (Courtesy of Lalo Gonzalez.)

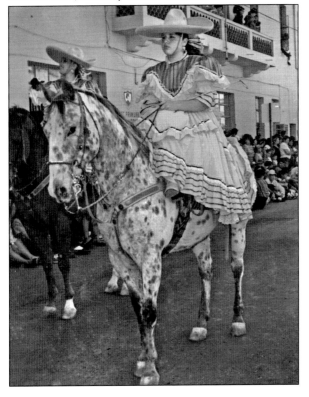

Over the years, the charro tradition has remained strong in Matamoros, with several active associations providing training and performances. Just as in American rodeos, Mexican women perform in *charreadas* and parades. These two *charras* ride sidesaddle past a Matamoros elementary school. (Courtesy of Lalo Gonzalez.)

Emmanuel, an immensely popular singer of the 1980s, was Mr. Amigo in 1985 and also visited Matamoros for Fiestas Mexicanas. He appeared in a convertible for a Matamoros parade but had to be closely protected by police from potentially overenthusiastic fans. He is probably best known for his million-seller 1980 album *Intimamente*. (Courtesy of Clemente Rendon.)

Below, just passing the *presidencia* (city hall) in Matamoros is the procession for a Fiestas Mexicanas event known as *Entierro de Mal Humor* (Burying of Bad Moods), an inaugural event reminiscent of Mardi Gras or *Carnaval* in other cities. The slightly macabre event, a tradition dating back to the pre-1940s *carnavales* in Matamoros, culminates at the Plaza Miguel Hidalgo. (Courtesy of Fiestas Mexicanas Committee.)

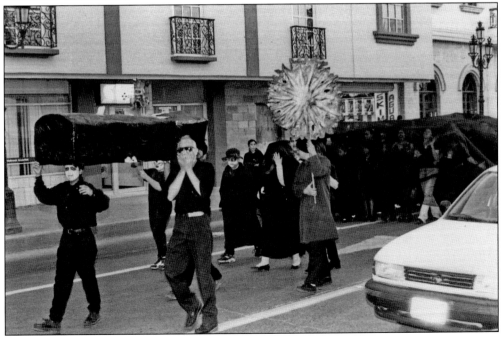

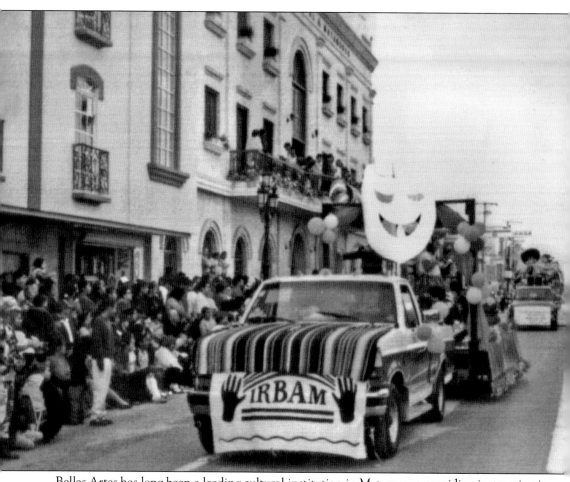

Bellas Artes has long been a leading cultural institution in Matamoros, providing instruction in the arts and cultural performances. In this scene, the Bellas Artes *carro alegórico* passes in front of the *presidencia* (city hall) across from the Plaza Hidalgo, bearing the laughing face of comedy as its symbol. (Courtesy of Fiestas Mexicanas Committee.)

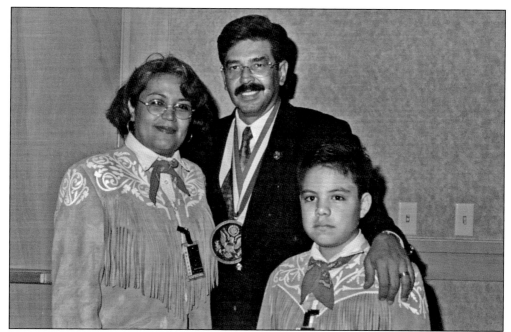

Mr. Amigo for 1998, comedic actor Jorge Ortiz de Pinedo, appeared at Matamoros venues as *Invitado de Honor* (Honored Invitee) of Fiestas Mexicanas. He is seen here with Olimpia López, a Matamoros official, and her son. Perhaps best known for his role as Dr. Candido Perez on television, Ortiz de Pinedo is still immensely popular today. (Courtesy of Olimpia Lopez.)

Presidente (Mayor) Mario Zolezzi of Matamoros poses with Fiestas Mexicanas participants. Immediately to his left is Rosaura Alicia Dávila, wife of *Cronista* (official historian) Andres Cuellar. Dávila de Cuellar collected information on the origins of Fiestas Mexicanas and has written a brief history of the celebration. (Courtesy of Fiestas Mexicanas Committee.)

The man with the voice of a child has entertained audiences in Matamoros many times, including Fiestas Mexicanas. "Chabelo" (Xavier López) was involved in the early days of Mexican television, and his show *En Familia con Chabelo* has been broadcast for more than 36 years. In 2007, he was invited as *Valor Nacional* (National Treasure). (Courtesy of Elia García Cruz.)

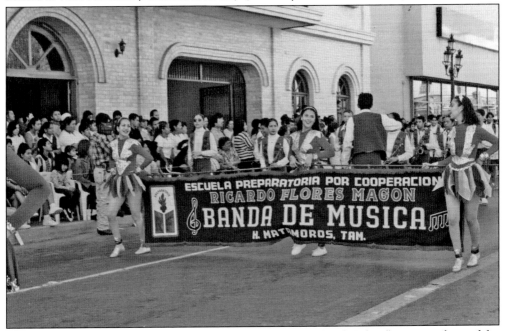

The marching band of the Ricardo Flores Magón Preparatoria (High School) passes in front of the *presidencia* (city hall) during a Fiestas Mexicanas parade in 1998. Matamoros high school bands are known for their spirited performances in Charro Days parades in Brownsville. (Courtesy of Prof. Arturo Sarabia.)

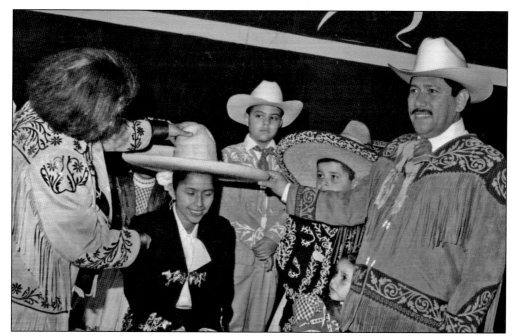

Matamoros presidente Homar Zamorano "crowns" the *reyna de charros* (queen of the charros) with a charro-style sombrero, assisted by Olimpia López. During Fiestas Mexicanas, several queens are selected but only one king, the *rey feo* (ugly king). This is a decades-old tradition of the festival. (Courtesy of Olimpia López.)

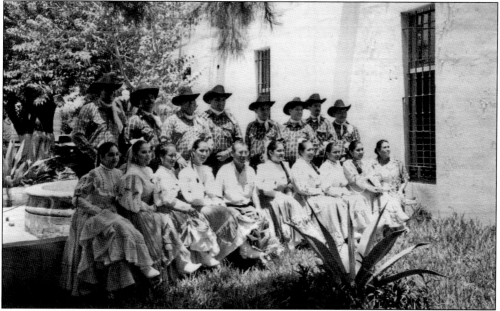

Mexican folkloric dancers pose by the Bellas Artes institute in Matamoros. They are dressed *norteño* (northern rural) style in the IRBAN (*Instituto Regional de Bellas Artes Nacional*) courtyard with the director at the time, Jaime Garza (seated, fifth from left). The Bellas Artes provided instruction for individuals and groups that participated in Fiestas Mexicanas. (Courtesy of Fiestas Mexicanas Committee.)

Two distinct styles of dress are seen in the queen selections for Fiestas Mexicanas. The girl in the formal dress was a participant in the Fiestas Mexicanas queen contest, while her companion may well have aspired to be queen of the charros. Residents of the *colonia* (neighborhood) have come out to the street to observe. (Courtesy of Mariana Hernández.)

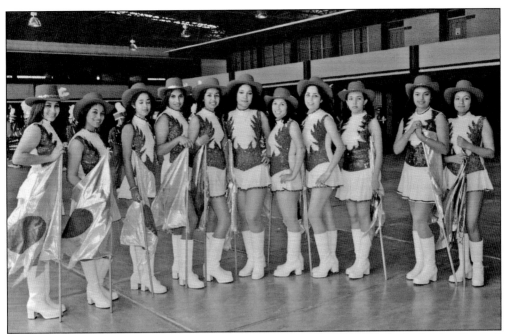

Porristas (cheerleaders) at the Preparatoria Ricardo Flores Magón, a Matamoros high school located close to the border, participated in the International Parade and Fiestas Mexicanas activities. The girls pose at their school as the band assembles behind them prior to a parade. *Viva las bellas porristas!* (Courtesy of Prof. Arturo Sarabia.)

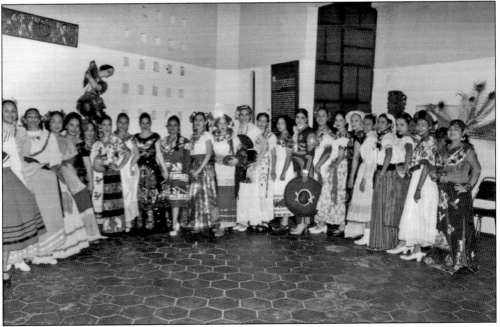

Matamoros ladies display their Fiestas Mexicanas finery for one of the numerous social events. Here they exhibit the wide variety of traditional folkloric dress from the different regions and eras of Mexico's past, ranging from charra and china poblana to Adelita, *jarocha* (Veracruz), and various Indian cultures. (Courtesy of Fiestas Mexicanas Committee.)

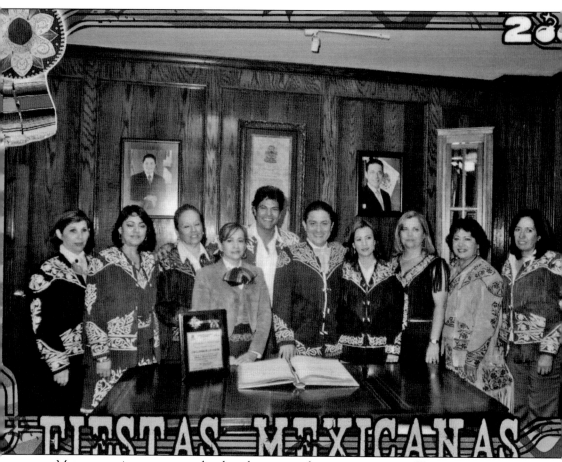

Matamoros city government has long been an enthusiastic supporter of Fiestas Mexicanas and its antecedents. This 2009 official photograph features the organizing committee together with the *presidente municipal* (mayor), Erick Silva Santos (hand on book), and his wife, Marisa Castañeda. Mayor Silva greeted Mayor Pat Ahumada of Brownsville at the border to inaugurate the festival. (Courtesy of Fiestas Mexicanas Committee.)

Three

THE GOLDEN YEARS

From the 1940s into the new century, Charro Days continued to attract crowds from both the United States and Mexico. During these golden years, Charro Days was featured in numerous documentary movies, magazine photo-essays, newspaper articles, and radio programs aired by the Voice of America. It was touted as the Fiesta of the Americas in travel brochures. Much of the popularity of the festivities was centered on the fact that the festival demonstrated that two cultures could exist side by side across an international border.

As time went on, more differences were seen in the activities offered. Through the golden years, fireworks along the banks of the Rio Grande and a Charro Days golf tournament were included in the growing list of activities.

The Charro Days of the late 1940s received a number of celebrity guests such as Xavier Cugat, Gov. Beauford Jester, Esther Williams, Desi Arnaz, Joan Crawford, and more. During this time, Charro Days was featured in *Life* magazine. During the 1940s, radio networks featured Charro Days' three grand balls in a coast-to-coast broadcast. The late 1940s also introduced model airshows and a ban on pistol toting by participants.

The changes continued, and in 1956, there was an art exhibition at Fort Brown, as well as a tricycle grand prix, talent shows, a tennis tournament, and Charro Days plays by Camille Playhouse performers. There was even a water-skiing exhibition at Fort Brown Resaca.

Downtown merchants got into the spirit of the festival and participated in show window displays entitled "History of Latin America Windows" in 1959. Athletic events included a marathon race, an acrobatic exhibition, and a weightlifting contest.

Then, in 1961, Charro Days was featured in *National Geographic* magazine. Coincidentally, the same year featured lighted floats for the first Illuminated Parade.

The fun and gaiety of the Charro Days fiesta remained strong throughout the golden years. The spirit of Charro Days continues on today and can still be seen in the ancillary activities such as Mr. Amigo and the Sombrero Festival.

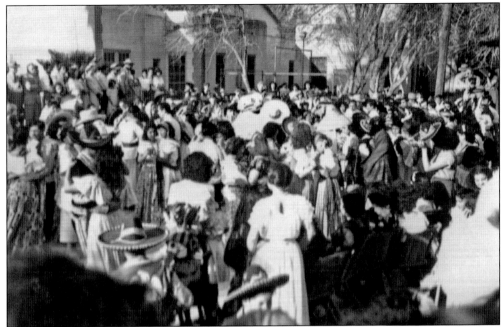

Public dances, such as this one held in the late 1940s, continued to be popular. While the upper class of Brownsville often attended private dances and balls, the public dances provided an opportunity for everyone in Brownsville to participate. Streets were roped off, and roving mariachis played for the crowds. In this photograph, most of the women are dressed as chinas poblanas, and men are dressed as charros. (Courtesy of Antonio N. Zavaleta.)

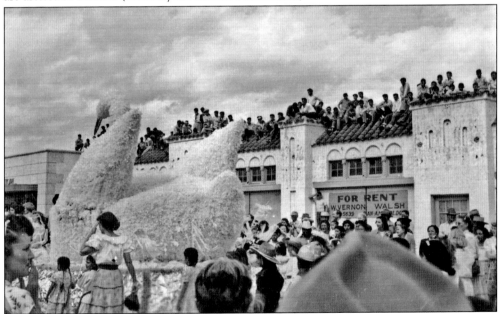

Young men are seen perched on top of a building to gain a better view of the Charro Days parade on Elizabeth Street. The Charro Days parades always drew huge crowds, and the lack of standing room caused many parade-goers to find alternative viewing positions. During the late 1940s, the Charro Days parades continued to attract a variety of participants. (Courtesy of Antonio N. Zavaleta.)

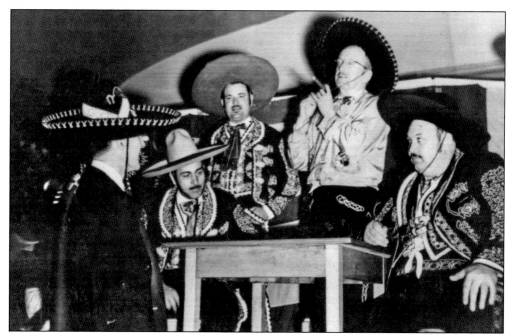

Brush Court is now in session, presided over by "Chief Injustice" Sam Perl (holding cigar), with faithful accomplice John Hunter seated on the far right. Perl and Hunter were among the founders and early organizers of Charro Days. A lay rabbi for Temple Beth El, Perl at one time had a radio show on which he always declared, "We love everybody." (Courtesy of BHA.)

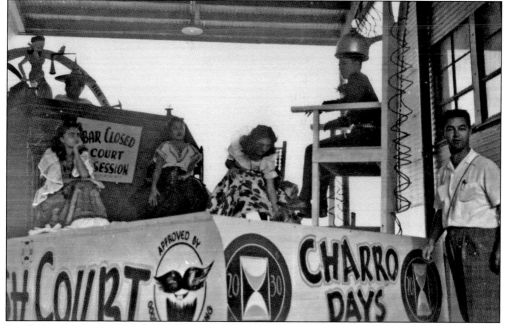

Brush Court continued to be a popular tradition. Men were expected to grow a beard for Charro Days, and those who did not were "tried" in Brush Court. While it appears that "Old Sparky" was a possible punishment, conviction usually resulted in a fine donated to local charities. (Courtesy of Antonio N. Zavaleta.)

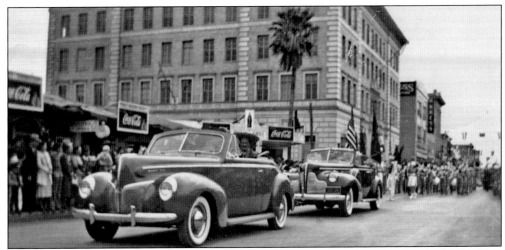

In this late-1940s parade, Kenneth Faxon, the founder of Charro Days, is seen in the back of this car dressed as a charro. By this time, many of the parade floats and horse-drawn carriages were replaced by automobiles. The background buildings show advertising for Coca-Cola products. The Kress building is shown in the background. (Courtesy of Antonio N. Zavaleta.)

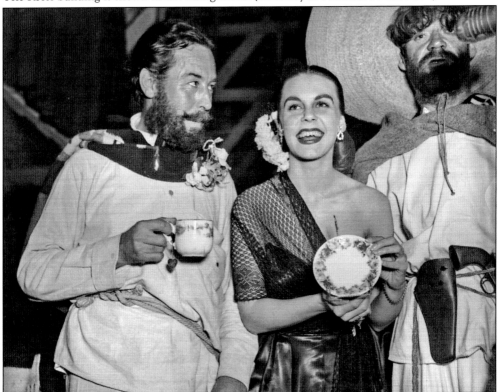

The incongruous nature of some Charro Days events is evident in this photograph of an armed *bandido* delicately displaying a china teacup. This early Charro Days social event shows Lefty Appleton and his female companion displaying china. Since Appleton was a member of the Charro Days committee, and given the way the china is displayed, the event was likely an auction or raffle fund-raiser. (Courtesy of Bob and Rachel Torres.)

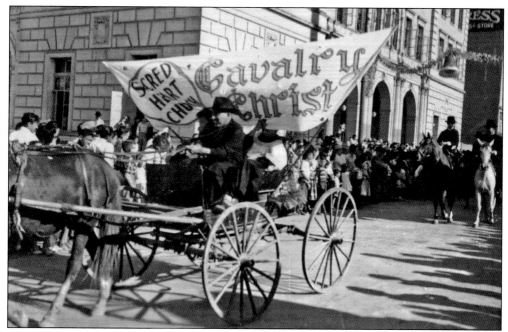

The Oblates of Mary Immaculate (OMI) participated in Charro Days parades as a way to inform the crowds about their mission. The OMI was founded in France in 1816 and became a mission-sending society of priests and brothers. They established a school in Brownsville in 1865 but had made Brownsville their first South Texas headquarters prior to that. They fanned out on horseback, serving the local ranch families, and were known as the "Calvary of Christ." In the above photograph, note the Calvary of Christ banner on a horse-drawn carriage. The photograph below shows a horse saddle that symbolizes the Calvary of Christ and a tribute to Padre Pierre Keralum, a well-known missionary circuit-rider and architect. Keralum designed and constructed the Immaculate Conception Church in downtown Brownsville and other churches in the area. Padre Keralum was later interred at the Immaculate Conception Church. (Both, courtesy of Antonio N. Zavaleta.)

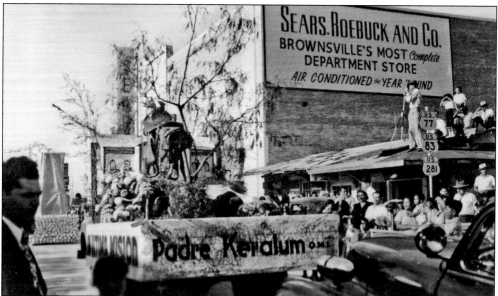

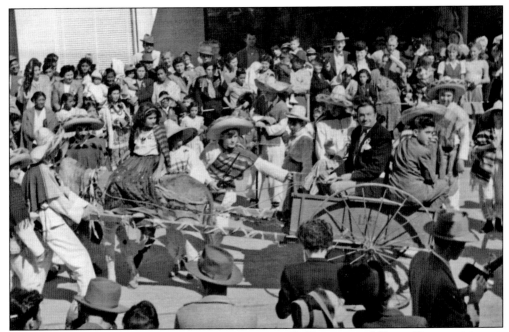

Famous bandleader Xavier Cugat is in a *carreta*, or cart, pulled by costumed Charro Days participants. The *bailes* (dances) of Charro Days often attracted big-name bandleaders to lead the orchestras. Cugat was famous for his renditions of the mambo, cha-cha, and conga, which all attracted a large following during the 1940s. He is credited with the infusion of Latin music into the popular American big band scene. (Courtesy of BHA.)

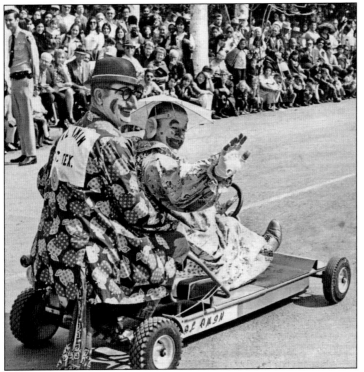

"Big Ernie" Shimmings (left) and Joe Alphin are seen on a small motorized cart during a Charro Days parade. They were part of the Shriners' club from the El Amin Shrine Temple in Corpus Christi, which had a tradition of appearing as clowns during the Charro Days parade. (Courtesy of Bob and Rachel Torres.)

In the mid- to late 1940s, the popular dress of choice for Charro Days continued to be the china poblana outfit. Many women used Charro Days as an opportunity to dress up in traditional garb and pose for photographs. This one is of Rosie Gomez, taken in 1945. (Courtesy of Rosie Gomez.)

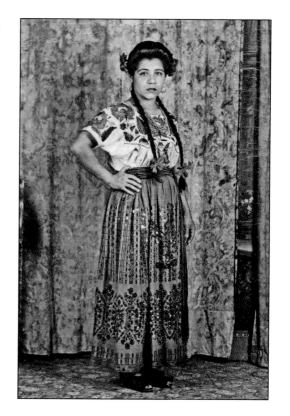

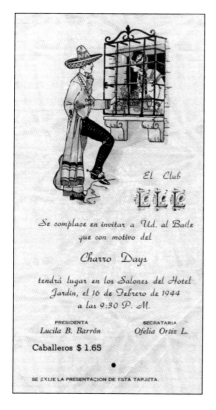

El Club

ĿĿĿ

Se complace en invitar a Ud. al Baile que con motivo del

Charro Days

tendrá lugar en los Salones del Hotel Jardin, el 16 de Febrero de 1944 a las 9:30 P. M.

PRESIDENTA
Lucila B. Barrón

SECRATARIA
Ofelia Ortiz L.

Caballeros $ 1.65

•

SE EXIJE LA PRESENTACION DE ESTA TARJETA.

Charro Days spawned several other organizations, especially "clubs." The Triple-L Club, comprised primarily of Brownsville's leading Mexican American citizens, was created in 1938. Like other clubs, the Triple-L Club sponsored public and private events, which were comprised mainly of dances. This 1944 invitation to a dance at the Hotel Jardin indicates that men (only) would be charged $1.65 admission. Other clubs included the Sarape, Damas y Caballeros, and Los Huaraches. (Courtesy of BHA.)

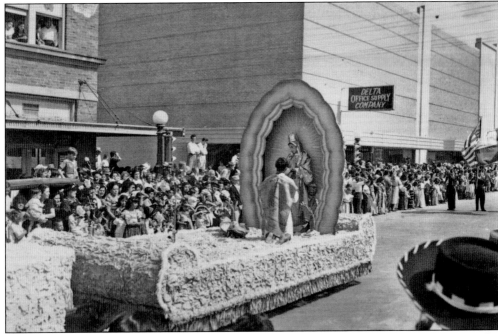

This photograph, taken in front of the Delta Office Supply Company, shows a float depicting the Virgen de Guadalupe and Juan Diego story. According to legend, the Virgin Mary appeared to an Indian peasant named Juan Diego in the spot where a church should be built to her. This event was a pivotal moment in the larger conversion of the native peoples of Mexico to Catholicism. (Courtesy of Antonio N. Zavaleta.)

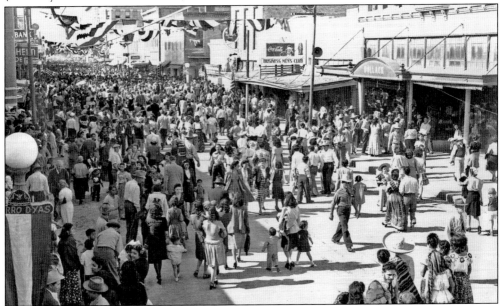

The extent of Charro Days crowds during the early golden years is evident in this photograph. This crowd on Elizabeth Street in front of the Bollack department store had probably just witnessed one of the parades. These massive crowds continue to appear for multiple parades year after year. (Courtesy of Gene Balch.)

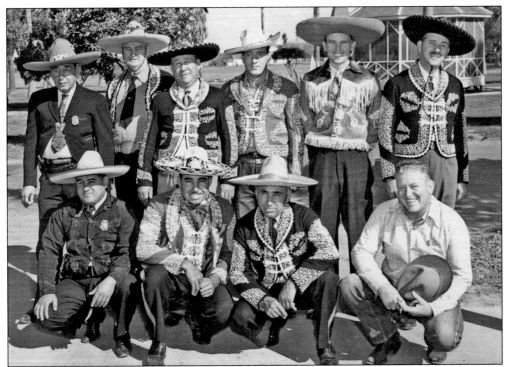

The Brownsville Police Department provided security, crowd control, and escort service during Charro Days. But the police were also participants themselves. Dressed in charro outfits, Brownsville's "Finest" posed near their headquarters in the administration building they inherited from the army at Fort Brown when it closed at the end of World War II. The photograph above shows police chief Gus Krausse and Cameron County sheriff Boyton Fleming (standing, fifth and sixth from left), while the one below shows both the chief and the sheriff on horseback (first and third from left). (Both, courtesy of Ruben Garcia.)

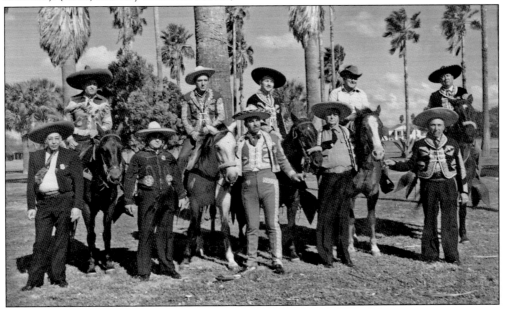

This late-1950s photograph of Minerva C. Lieck shows her dressed for Charro Days in an outfit that departs from the traditional china poblana outfit. While her skirt has what looks like an indigenous Mexican motif, the outfit is updated, which is a sign of the times. As Charro Days continued through the decades, women explored other traditional costumes and even sewed their own clothes in variations of the traditional classics. In the background, one can see part of the sign for the Majestic Theater. (Courtesy of Minerva C. Lieck.)

Brownsville mayor Gene McNair (right) joins Virgilio Uribe, *alcalde* (mayor) of Matamoros, at the presentation of a Charro Days trophy. McNair, owner of a textile factory, served as mayor from 1961 to 1963. He was a founder and longtime president of the Historic Brownsville Museum. (Courtesy of Bob and Rachel Torres.)

Holding Charro Days pamphlets in 1963 are Joe Calapa (left) and Steve Bosio. Calapa was the owner of J&O Menswear, a fashionable men's store on Elizabeth Street. One can see the Charro Days–themed objects in the background. Bosio was the head of the chamber of commerce. (Courtesy of Bob and Rachel Torres.)

These bandidos, businessmen, and charros are ready for a Charro Days party. Pictured from left to right are (first row) Oliver Clark, Bobby Putegnat, two unidentified, Donald Ferguson, and unidentified; (second row) Joe Calapa, Bob Sobrino, J. B. Vance, Butch Schultz, Frank Voltaggio, Albert Gay, Vance Wilson, Buster Stevenson, and Steve Bosio. (Courtesy of Bob and Rachel Torres.)

This Charro Days photograph shows the cross-generational appeal that Charro Days continued to have during the 1950s and 1960s. Here Minerva C. Lieck can be seen with her son Edgar D. Lieck. (Courtesy of Minerca C. Lieck.)

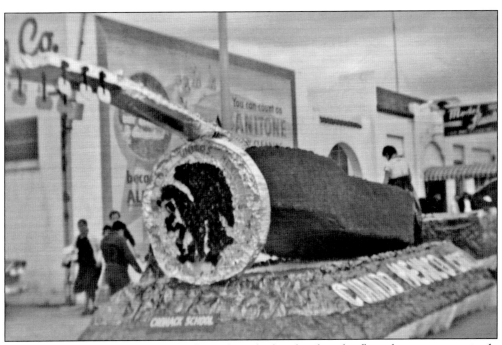

As Charro Days continued and the festival reached its heyday, the floats became increasingly complex. This float shows a guitar, a popular Charro Days symbol, with the words "*Cuando Mexico Canta*," or "When Mexico Sings." The float was sponsored by Cromack Elementary and is one of many throughout the years that was sponsored by a school. (Courtesy of Blanca Trevino.)

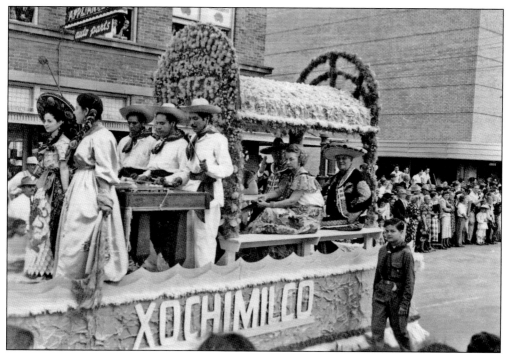

This 1940s version of the "floating gardens" of Xochimilco shows that this theme, which was started in the first Charro Days parades, continued on into the golden years. Xochimilco boats were named for the wives or *novias* (girlfriends) of the boat operator. This one is named for a woman named Ester. (Courtesy of Dr. Tony Zavaleta.)

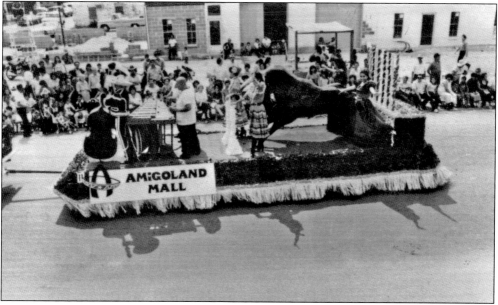

Marimba music, pretty girls in Mexican costumes, and a papier-mâché bull ready for the *plaza de toros*—what more could be asked for a single float? Amigoland Mall, the float's sponsor, was Brownsville's first mall, built near the Mexican border in 1974. Today the structure is part of the University of Texas at Brownsville. (Courtesy of BHA.)

This 1960s Charro Days float featuring a sombrero and a serape is being assembled before the big parade. In the photograph are Tommy Monk (in hat) and members of the Charro Days committee. Also in the photograph watching the work on the float is Mike Puckett (third from left). Puckett later became the longtime executive director for Charro Days, Inc., the nonprofit organization that oversees Charro Days activities. (Courtesy of Bob and Rachel Torres.)

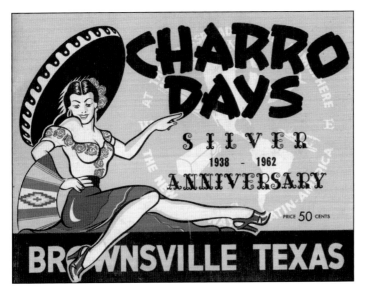

The silver anniversary program for Charro Days contained a stream-of-consciousness history of the first 25 years, including essential information for this book. The cover image obviously contains a touch of sex appeal as well as the somewhat obscured slogan, "At the Crossroads of the Hemisphere—The New Highway to Latin America." (Courtesy of BHA.)

This 1965 Charro Days program shows romanticized versions of Mexican men and women depicted in the style of Mexican Calendar paintings. These paintings were used to create the popular Mexican calendars used to promote Mexican American businesses. Although some of the Charro Days dresses used by women had been modified and adapted by regional influences during this time period, the Charro Days programs of this decade continued to use the traditional images from the original Charro Days celebrations. (Courtesy of BHA.)

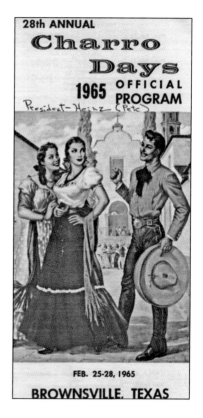

The 1997 Charro Days celebration was the 60th anniversary of the founding of the event. The official program that year was an "initial costume souvenir" containing photographs of many costumes from different regions of Mexico. These costumes were provided and modeled by members of the Pan American Roundtable No. 1 and others. Among the costumes were the Adelita, the china poblana, the Jarocha, and the Chiapaneca. (Courtesy of BHA.)

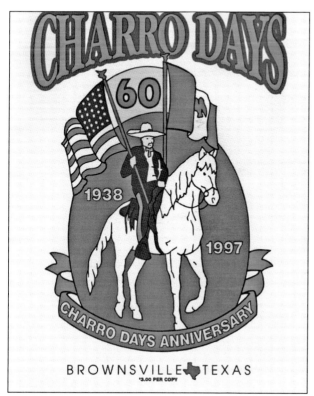

The promotional brochure for the 1995 Charro Days portrays two charros, one Mexican and the other American. Each carries a pole displaying his nation's flag. In recent times, Charro Days, Inc., has commissioned an official poster on some aspect of the celebration. This image promoted the concept of shared culture. (Courtesy of BHA.)

Why not mascots for Charro Days? For years, Brownsville had "Goldie and Gus" as mascots for the swimming program, so the appearance of "Pancho and Margarita" in the mid-1990s seemed like a good idea. Of course, the mascots would represent the charro and his china poblana. Children were especially fond of Pancho and Margarita. (Courtesy of BHA.)

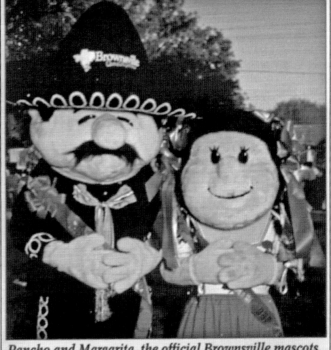

Pancho and Margarita, the official Brownsville mascots, take part in Charro Days festivities.

Four

THE ROLE OF CHILDREN

Children have always provided an essential focus for Charro Days. Youngsters from pre-kindergarten through college love to participate in the parades and dances, and show off charro costumes. Parents often attend and participate, primarily to observe and support their children.

Every year, there has been a Children's Parade involving school bands, floats, drill teams, and dancers. In the early years, Brownsville High School provided costume reviews and dances with the aid of the Pan American Roundtable. Poster contests and the 1944 Fiesta de Mexico at the high school stimulated interest in celebration activities.

From the beginning, children have been beguiled by Charro Days carnivals, including the George Loos Carnival in the 1940s. The early years also saw the shenanigans of the junior version of the "bandidos." Congregating in a palapa shack in front of the Missouri Pacific Railroad Depot after school, teenage boys dressed as peons would stage bandit raids on a local bank, snarl traffic, and engage in general mischief, all to the great amusement of tourists. At dusk, however, recalled Paul Gilmore, he had to go home "to milk the cow."

For many years, a children's event has marked the beginning of Charro Days. In 1953, Villa Maria High School and Incarnate Word Academy inaugurated "A Little Bit of Mexico," initially a costume-style show but soon a full-fledged folkloric dance extravaganza. Renowned choreographers from Mexico helped students prepare for the event as part of the curriculum. Since the closing of Villa Maria, Incarnate Word has continued the tradition.

The major player in the involvement of children for decades has been the Brownsville Independent School District (BISD). BISD produces the Children's Parade, the annual first parade of Charro Days, comprised of 80 to 100 elements. Earlier in the week, BISD sponsors the Fiesta Folklorica at Sams Stadium behind the original high school. In recent times, the students have performed traditional dances on a floor in the center of the field while food is provided from booths on the perimeter. Since there are now 52 schools, only one-fourth are able to participate each year, on a rotational basis.

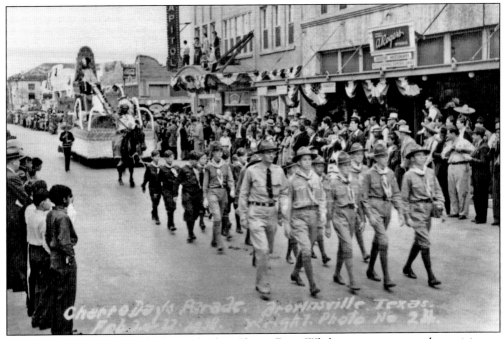

There was a Children's Parade during the first Charro Days. While many young parade participants represented schools, some marched as representatives of various church and civic organizations. In this 1938 photograph, a troop of Boy Scouts is in the lead, followed by Cub Scouts and a horse-drawn float. At the far left is the old Vivier Opera House, while the Capitol Theater and its still-functioning sign appear in the center. (Courtesy of BHA.)

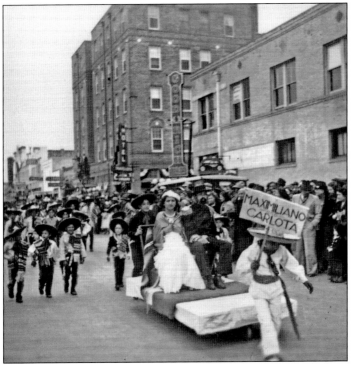

A youngster dressed as a *campesino* (rural farm worker) carries a sign proclaiming the tiny float bearing a boy and girl portraying Maximillian and Carlotta. The star-crossed Austrian archduke and his bride came to Mexico during the French intervention of the 1860s to become emperor and empress. Maximillian's tragic execution added to the fascination with this historic episode. In the early years, Charro Days made a strong effort to educate and inform about Mexican history. (Photograph by Les Mauldin; courtesy of BHA.)

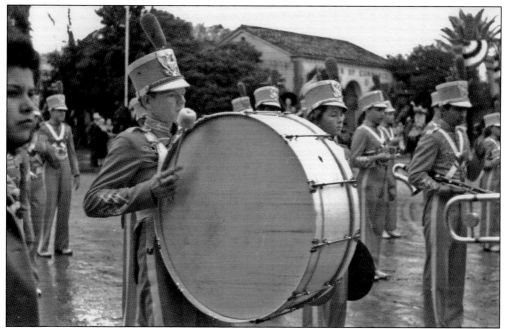

Bands are an essential part of any parade, and they have always been especially important to the Children's Parade. Military bands from Fort Brown and Mexico provided a professional touch in other parades, but the Children's Parade depended on bands from the schools. This photograph features the bass drum (and drummer) of the Brownsville High School Band of 1942, as identified by longtime director Bob Vezzetti, who noted the formal "tails" on the uniforms. (Photograph by Arthur Rothstein; courtesy of Library of Congress.)

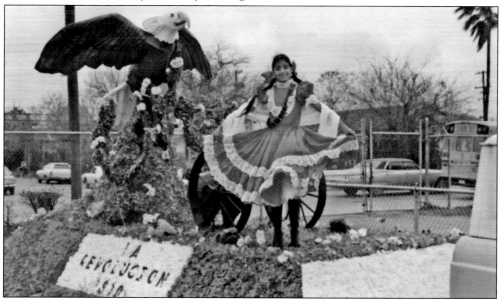

This Clearwater Elementary School float was the winner of the first prize in 1970. It featured a Mexican Revolution theme with eight-year-old Debra Dominguez displaying the Adelita dress made by her grandmother as she stands in front of a cannon. Around her shoulder is an authentic cartridge bandolier from the revolution. (Courtesy of Gloria Dominguez.)

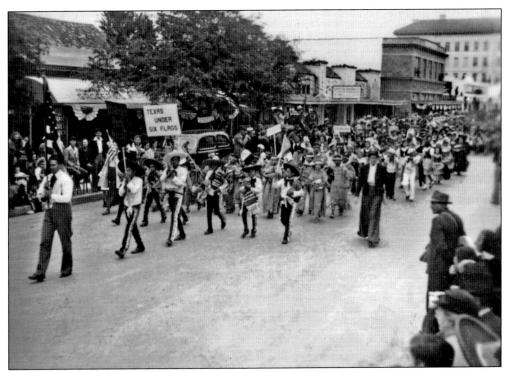

The historical education efforts of the first Charro Days in 1938 were clearly evident in the parades. A significant component of one of the parades was the "Texas Under Six Flags" theme, introduced by children garbed in varied costumes, as shown in the photograph above. The governments whose flags had flown over Texas were announced with signage as floats and marching units passed by. In the photograph below, a student marching band follows the sign proclaiming the United States as the ultimate sovereign of Texas, succeeding Spain, France, Mexico, the Republic of Texas, and the Confederacy. (Above, photograph by Les Mauldin; courtesy of BHA; below, courtesy of Chula Griffin.)

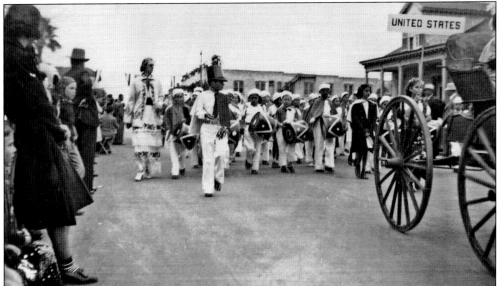

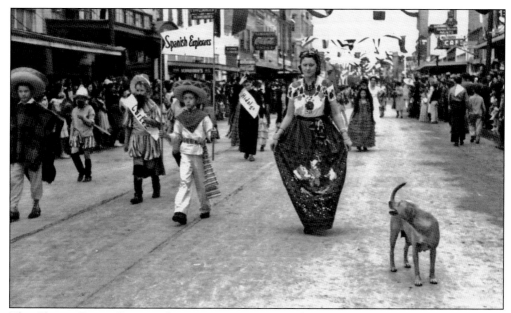

The Charro Days effort at education on Mexican and Latin American history and culture continued in 1942. In this glimpse of the Children's Parade of that year, one student bears a banner announcing the advent of Spanish explorers, closely followed by another portraying Hernan Cortez, conqueror of the Aztecs. Pets were involved in the early Children's Parades, but the canine here was probably a renegade. (Photograph by Arthur Rothstein; courtesy of Library of Congress.)

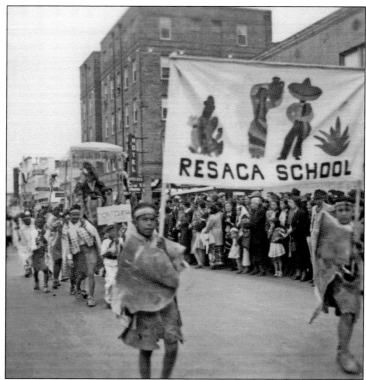

From the beginning, Charro Days was interpreted as covering all things Mexican. In a parade during the first Charro Days, students from Resaca Elementary School march as Mexican Indians, possibly Aztecs. "Resacas" is the local term for former channels of the Rio Grande; many homes and businesses are located on the banks of resacas. In the background is the Travellers Hotel, which is still a hotel today under the "Colonial" name. (Photograph by Les Mauldin; courtesy of BHA.)

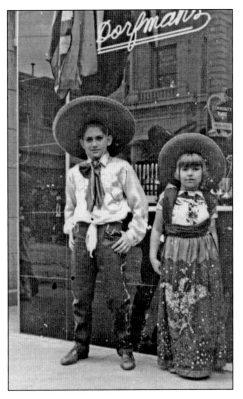

Henry Hausman and Sarah May Dorfman are dressed in their Charro Days outfits for the first celebration in 1938. They stand in front of Sarah May's father's store on Elizabeth Street. Dorfman's was one of Brownsville's premier jewelry stores. Isadore Dorfman's grandson Jules Frapart continued the family jewelry business tradition at a location in Palm Village. (Courtesy of BHA.)

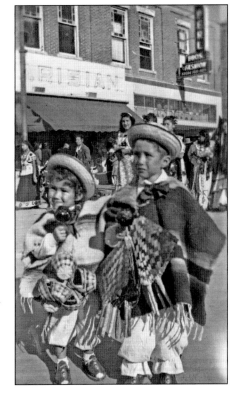

At an early Charro Days parade, two young children pose as marchers pass by. The little girl appears to represent a basket-vendor; both children wear the traditional serape, the clothing/blanket of the rural highlands of Mexico. In the background is Perl Brothers haberdashery, whose owner, Sam Perl, was lay rabbi for Temple Beth-El and "chief injustice" of the Charro Days Brush Court. (Photograph by Les Mauldin; courtesy of BHA.)

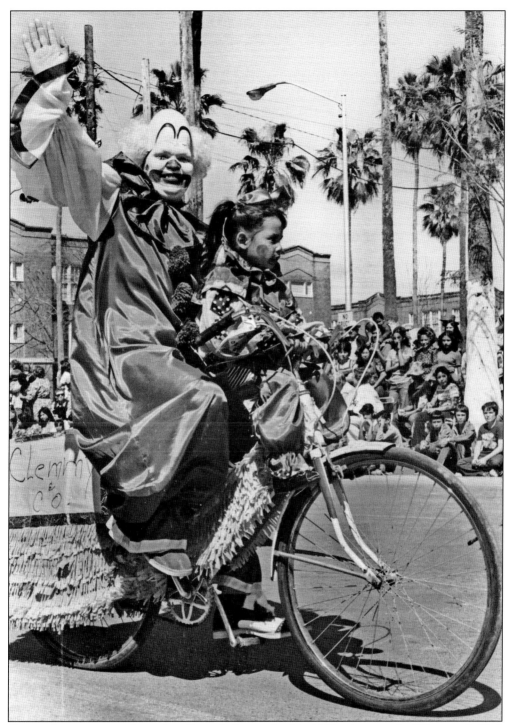

Carnivals, circuses, and parades all need clowns. In this 1960s photograph, "Clemmy & Co." presents its bicycle "float" along the parade route in front of the Brownsville High School. A small girl has taken up the role of apprentice clown but has her eyes firmly fixed on the road ahead. (Courtesy of Bob and Rachel Torres.)

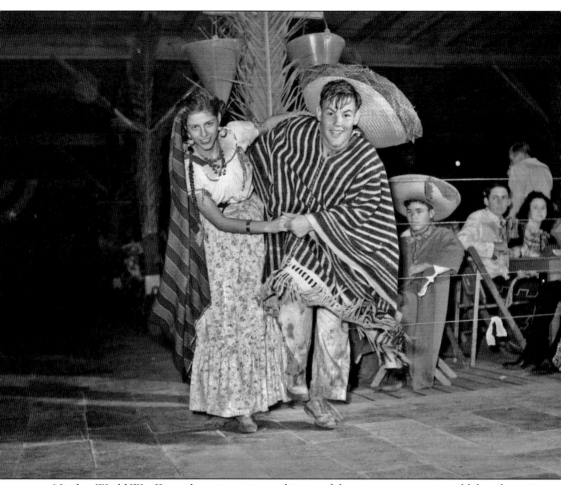

Neither World War II nor the uninspiring ambiance of the cotton compress could dim the spirits of Charro Days' youth in 1942. The cotton compress was transformed to the extent possible into "El Rancho Grande," the site for several dances and parties. In this photograph, teenage jitterbugs demonstrate their undiminished exuberance. (Photograph by Arthur Rothstein; courtesy of Library of Congress.)

From the beginning, cultural education has been a primary focus of Charro Days. Brownsville schools devoted time, effort, and study to informing students, mostly Mexican Americans, about their Mexican heritage. In this scene, students have already donned their costumes as they learn about Mexican arts and crafts during Mexican American week. Many students would also march and perform dances in the Children's Parade. (Courtesy of BHA.)

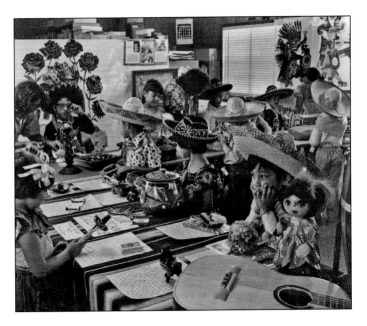

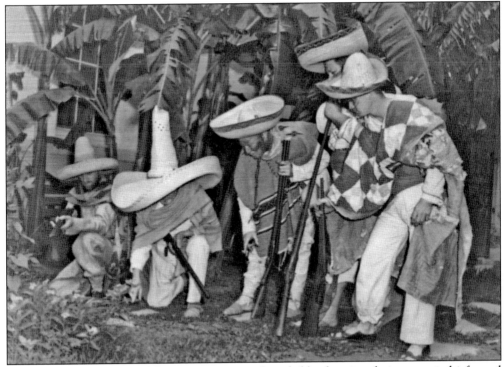

It looks as though the *bandidos* are up to no good, probably planning their next mischief—and corrupting young recruits in the process. In all likelihood, that is "jefe" Wiley Truss under the monstrous sombrero, with Cuban Monsees between him and the teenage delinquents. The "poncho" on the bandido on the right appears to be an old quilt. (Courtesy of Chula Griffin.)

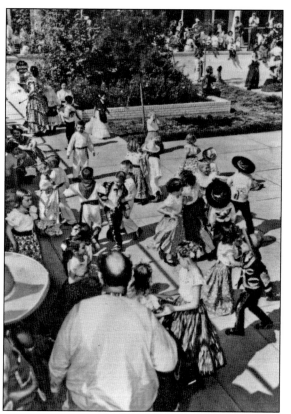

An early version of BISD's Fiesta Folklorica was the Fiesta de los Niños (Children), Mrs. A. A. Hargrove's idea of children's participation in Charro Days. In this *c.* 1977 scene, costumed children dance at the Jacob Brown Memorial Civic Center. The event was soon redirected to children in day care centers and performed at the (later demolished) Friendship Gardens by the Rio Grande. In the 1990s, the event became Baile de los Niños, performed at Sombrero Fest. (Courtesy of BHA.)

Grammar school students dressed as *campesinos* demonstrate the traditional transportation of water. One lad carries two large tins of water on his shoulders balanced by a pole. In front, a mock "mule" pulls a cart bearing a large barrel of water as a young "pipero" holds the reins. Piperos brought water from the Rio Grande to Brownsville households prior to the installation of the city water system. (Courtesy of Antonio N. Zavaleta.)

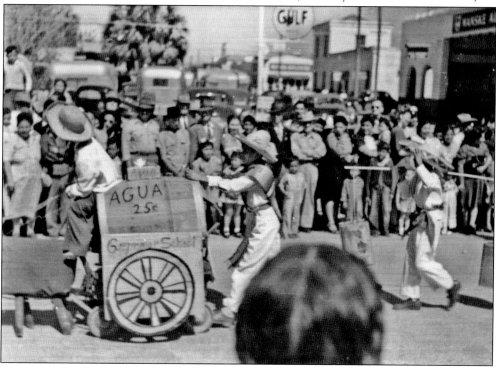

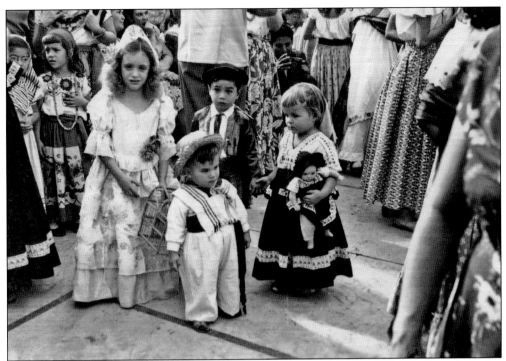

At one of the many Charro Days events around 1949, probably on the patio of the El Jardin Hotel, youngsters display their costumes. The young boy and girl holding hands portray a *torero* (bullfighter) and his *novia* (sweetheart). The doll in the girl's arm wears an identical costume. The tiny boy in front represents a Mexican bird vendor, occasionally still found in Mexican markets today, with a cage on his back. (Courtesy of Antonio N. Zavaleta.)

The Iglesia Presbiteriana Mexicana (Mexican Presbyterian Church) is the product of a Spanish-language Presbyterian involvement in Brownsville dating to the 1870s. A student member of the congregation, Karl J. Lieck, took the responsibility for personally creating the church's float for the 1976 Charro Days parades. The float features a representation of a U.S. silver dollar. (Courtesy of Minerva C. Lieck.)

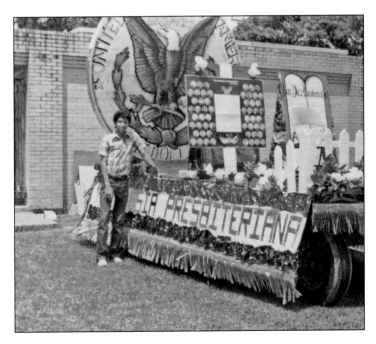

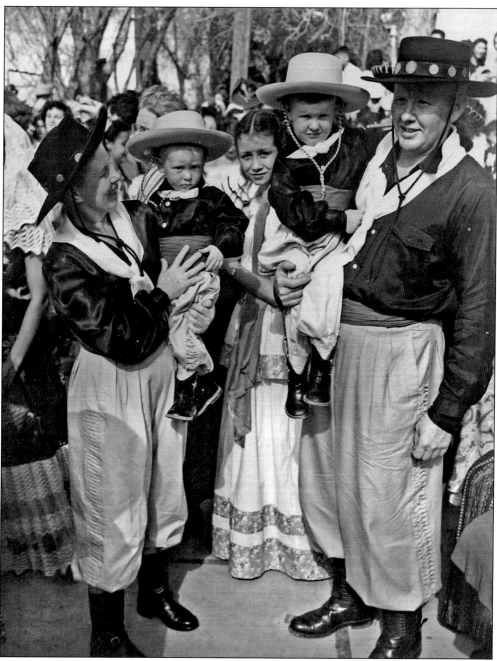

Children Steve (left) and Gerald Clark wear gaucho outfits created for them by their grandmother based on the authentic costumes brought back from Brazil by their parents. Kenneth Clark and his wife, Margaret Monroe Clark, had travelled to Brazil for Clark's employer, Pan American Airways. Margaret Clark became an icon of Brownsville education, best known for teaching generations of Brownsville children how to swim. (Courtesy of Kathleen Clark Walker.)

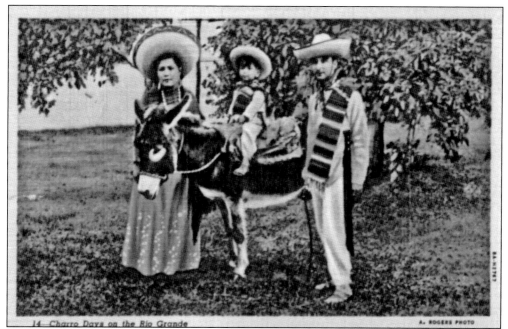

14—Charro Days on the Rio Grande A. ROGERS PHOTO

Several photographers produced postcards in the early years of Charro Days. This one, by A. Rogers, was mailed in 1944. No doubt the photographer believed that a small child seated on a burro would make an appealing—and saleable—image. He was probably right. (Courtesy of Alma Ortiz Knopp.)

Florestela and A. X. Benavides pose in their traditional Charro Days outfits in front of the First Presbyterian Church on the corner of Elizabeth Street and Palm Boulevard as the crowd seated on the steps awaits the parade. A. X. Benavides was a longtime school administrator who brought federal education programs to Brownsville. Now in retirement, he was honored in 1999 with the naming of a new elementary school. For many years, he and Oscar Barbour organized the Children's Parade for BISD. (Courtesy of BISD.)

For many years, public schools in Brownsville constructed floats for use in the Children's Parade, but the practice was eventually terminated because the schools became too competitive in their quest for the prizes that were awarded. This Cromack Elementary School float from the mid-1950s (above) displays an American flag and a Mexican national symbol behind a model of the international bridge between Matamoros and Brownsville. A student Uncle Sam stands in front of the bridge. Teacher Mary Saenz faces the camera from the motorized portion of the float. Two students stand in an Ebony Heights (now R. L. Martin) Elementary School float (below) from the early 1960s. Standing in front of the float are administrators Richard Treviño (left) and ? Burlingame. (Both, courtesy of Blanca Treviño.)

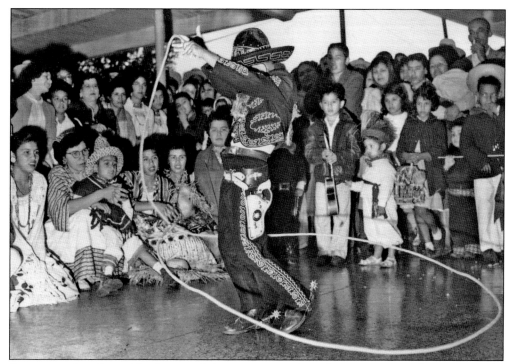

A young student dressed in charro style but incongruously packing a six-gun performs rope tricks with a lasso. This performance may well have occurred at a Fiesta de los Niños event for young children and their parents, probably in the 1960s. (Courtesy of Bob and Rachel Torres.)

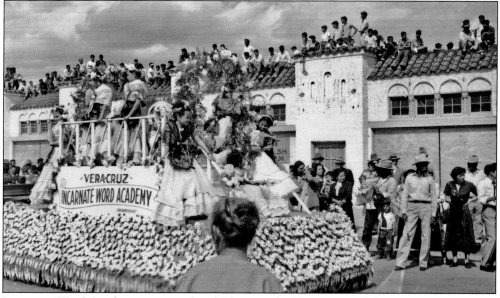

Incarnate Word Academy originated with the arrival of four sisters of the Incarnate Word and Blessed Sacrament order in Brownsville in 1853. The Catholic girls' school constructed this float (around 1949) to showcase the ornate white dresses and embroidered black aprons of the *jarochas* of Veracruz. Crowds along the parade route were often so dense as to prompt youngsters to climb to the roof of an adjacent building. (Courtesy of Antonio N. Zavaleta.)

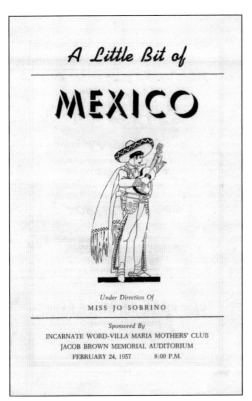

A Little Bit of

MEXICO

Under Direction Of
MISS JO SOBRINO

Sponsored By
INCARNATE WORD-VILLA MARIA MOTHERS' CLUB
JACOB BROWN MEMORIAL AUDITORIUM
FEBRUARY 24, 1957 8:00 P.M.

In 1953, Villa Maria High School began a small-scale style show that soon grew into a major production of traditional Mexican folkloric dances. When the high school closed, Incarnate Word Academy carried on. Preparation for the event is integrated into the curriculum as students experience the fine arts through dance and music, and history lessons on aspects of Mexican culture. The production culminates in the recognition of outstanding students as the charro and the china poblana, which then serves as a fund-raiser for the school as well as the inaugural event of the Charro Days celebration. The program cover is from 1957, while the list of dances is from 1989. (Both, courtesy of Incarnate Word Academy.)

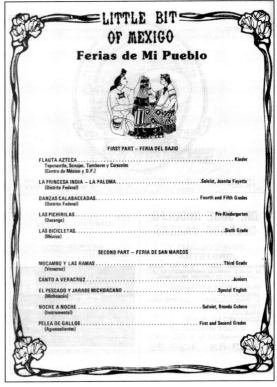

LITTLE BIT OF MEXICO
Ferias de Mi Pueblo

FIRST PART – FERIA DEL BAJIO

FLAUTA AZTECA . Kinder
Teponextle, Sonajas, Tambores y Caracoles
(Centro de México y D.F.)

LA PRINCESA INDIA – LA PALOMA . Soloist, Juanita Fayette
(Distrito Federal)

DANZAS CALABACEADAS . Fourth and Fifth Grades
(Distrito Federal)

LAS PICHIRILAS . Pre-Kindergarten
(Durango)

LAS BICICLETAS . Sixth Grade
(México)

SECOND PART – FERIA DE SAN MARCOS

MOCAMBO Y LAS RAMAS . Third Grade
(Veracruz)

CANTO A VERACRUZ . Juniors

EL PESCADO Y JARABE MICHOACANO . Special English
(Michoacán)

NOCHE A NOCHE . Soloist, Brenda Cubero
(Instrumental)

PELEA DE GALLOS . First and Second Grades
(Aguascalientes)

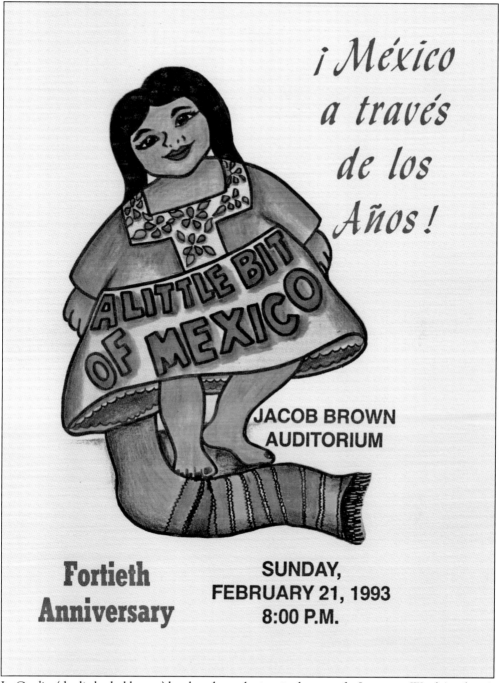

¡ México a través de los Años!

A LITTLE BIT OF MEXICO

JACOB BROWN AUDITORIUM

Fortieth Anniversary

SUNDAY, FEBRUARY 21, 1993 8:00 P.M.

La Gordita (the little chubby one) has long been the iconic character for Incarnate Word Academy's A Little Bit of Mexico folkloric dance production. She appears here on the cover of the program for a recent performance. The intricate dances of the event are performed by students from pre-kindergarten through eighth grade, all appropriately costumed. Many of the students are Mexicans from Matamoros who cross the border daily to attend school. (Courtesy of Incarnate Word Academy.)

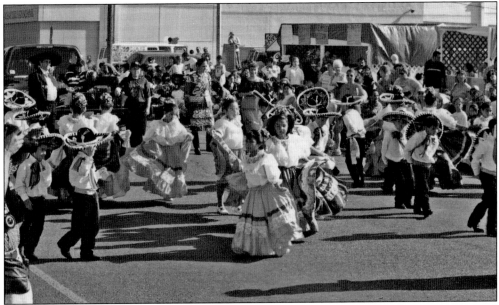

For decades, Brownsville elementary school students have learned to perform Mexican and Latin American folkloric dances in anticipation of the Children's Parade. Actually performing the dances during the course of the parade can constitute a "logistical nightmare," according to BISD public relations officer Drue Brown, because a performance temporarily holds up the parade. (Courtesy of BISD.)

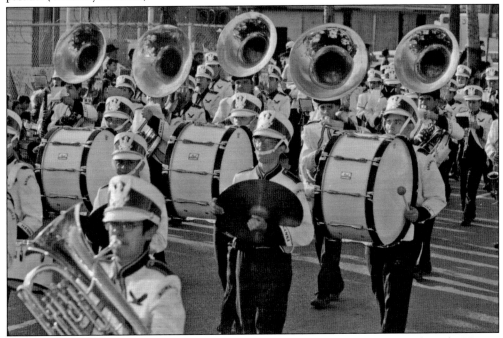

High school bands continue to play a prominent role in recent Charro Days parades. The Homer Hanna High School Band, pictured here, features multiple bass drums and sousaphones as bands have expanded in size since the early years. Brownsville now has five public high schools (and bands), plus St. Joseph Academy. (Courtesy of BISD.)

It is not all basses and drums in the Charro Days bands. In this 2000 portrait, a serious young Homer Hanna High School band member, Ronajae Page, holds her flute at the ready in anticipation of the next performance. The Children's Parade has been the first Charro Days parade for many years, usually occurring on a Thursday afternoon, with BISD classes dismissed at noon. (Courtesy of BISD.)

High school and middle school bands are essential for the performances of the school drill teams by providing the rhythms for the team's routines. The charro-clad girls' drill team in this photograph manipulates banners bearing combined Mexican and American flags. For many years, the Children's Parade has been produced by the Brownsville Independent School District. (Courtesy of BISD.)

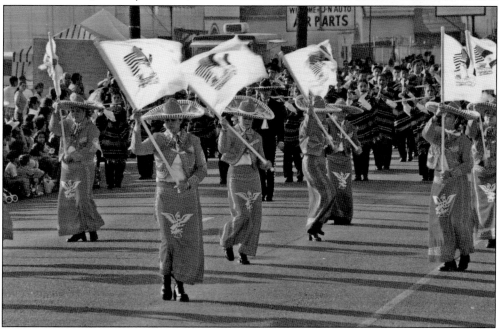

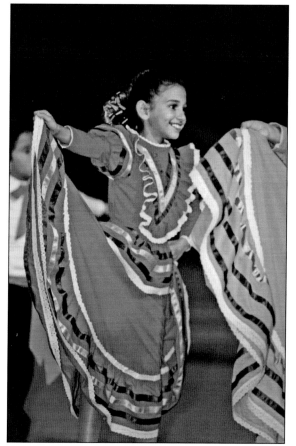

During the early years, some event always provided traditional Mexican music, costumes, and dances. In recent times, the Brownsville Independent School District has sponsored and produced the Fiesta Folklorica at Sams Stadium. Originally the singers and dancers performed before the stands while food booths provided typical *antojitos* (snacks) in the center of the field; now the order is reversed. Brownsville now has so many public schools (52) that a rotation has been established for participation by performers. The Fiesta Folklorica occurs on Monday night of Charro Days week—one of the earliest events. The smiling "Adelita" (left) wears a *norteño* (northern Mexico) costume of the revolutionary era. In traditional costume of these musical groups, student mariachis (below) perform "the sound of Mexico"—its traditional music. (Both, courtesy of BISD.)

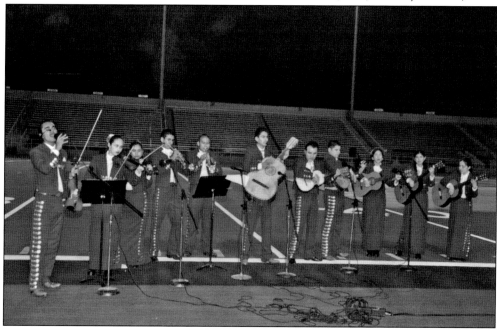

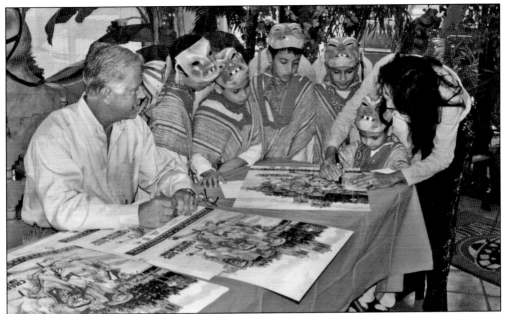

One of the more modern Charro Days traditions is the poster, which often features children in a regional costume. In the photograph above, students sign their individual representations in the poster as artist Don Breeden looks on. Breeden, an acclaimed Brownsville artist, has provided several of the posters. Sales of posters help raise funds for Charro Days. This poster shows students performing the dance of the *viejitos* from the Patzcuaro region of the state of Morelia. The masked dancers initially appear to be arthritic elders, but during the course of the dance, they become incredibly limber and athletic. As part of the poster-signing ceremony, the students perform their dance (below), beginning as old men with back pain, barely able to walk. (Both, courtesy of BISD.)

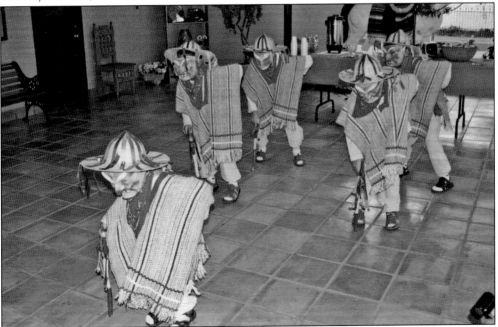

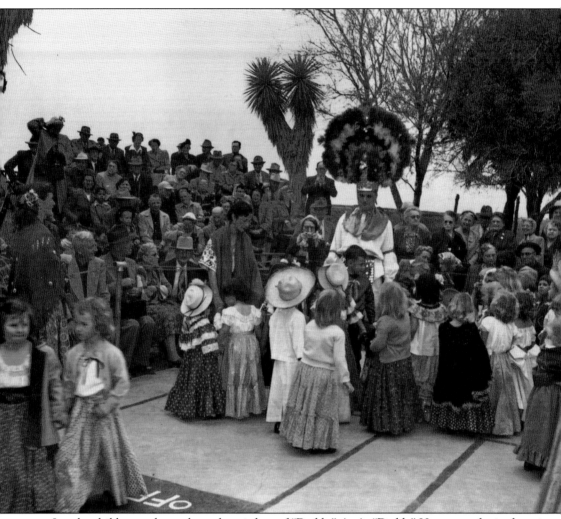

Let the children gather to hear the wisdom of "Daddy." A. A. "Daddy" Hargrove of *grito* fame is located immediately below the monstrous Indian headdress, basking in the regard of the assembled children. This event was an early version of Fiesta de los Niños as the small children entertain parents and tourists in the stands. (Courtesy of BHA.)

Five

MR. AMIGO

In the early 1960s, a few members of the Brownsville Chamber of Commerce created the Mr. Amigo Association to promote and publicize United States–Mexico relations and the international friendship between the border cities of Brownsville, Texas, and Matamoros, Tamaulipas. To convey this, a Mexican citizen who had contributed to the bilateral relationship between the two countries would be designated as "Mr. Amigo." Nominees were required to be Mexican citizens dedicated to improving the quality of life and serving as role models for Hispanic communities. Historically, honorees have been chosen from many occupations and professions, including politics, business, acting, comedy, and music. The Mr. Amigo celebration was not part of Charro Days until the late 1960s.

In October 1964, Miguel Aleman, former president of Mexico, received the first Mr. Amigo award. In 1965, Mario Moreno, "Cantinflas," beloved comic and movie star, was the second recipient. In the 1970s, Mr. Amigos included television celebrity Raul Velasco and singers Pedro Vargas and Tito Guizar. Movie actors and singers during that decade included Vicente Fernandez and David Reynoso. In 1979, the first female Mr. Amigo, Lola Beltran, queen of the Mexican *ranchera* song, was honored. The 1980s recipients included Juan Gabriel, composer and singer; Emanuel, matador and singer; and Lucia Mendez, soap opera actress and singer. Among the honorees of the 1990s were Veronica Castro, actress, singer, and television host; Gustavo Petricioli, Mexican ambassador to the United States; and Lucha Villa, Mexican folk singer and actress. Honorees since 2000 include Sergio Bustamante, artist and sculptor, and Lucero, actress and singer.

During the Charro Days festival, the Mr. Amigo Association hosts three events, including a *Bienvenida*, or welcome, an Award Party, and the President's Party, a big dance and dinner for Mr. Amigo. During the 1970s, Raúl Velasco, host of the internationally popular variety show *Siempre en Domingo* (Only on Sunday) aired the Charro Days fiesta and Mr. Amigo to a worldwide audience of more than 100 million. Today Mr. Amigo continues to be an integral part of the Charro Day tradition.

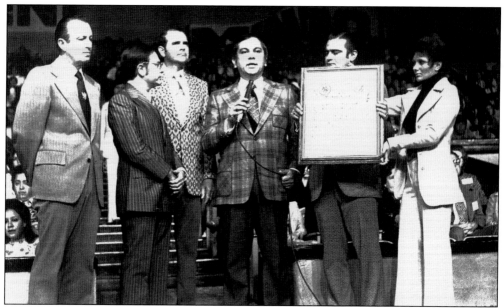

Members of the Mr. Amigo Association and the Brownsville business community appear on the *Siempre en Domingo* show in Mexico City with 1974 Mr. Amigo Raúl Velasco. Pictured from left to right are Steve Bosio from the Brownsville Chamber of Commerce, Velasco, Brownsville mayor Jim Mills, Mr. Amigo Association member Bob Torres, Gene Anastis (president of the Mr. Amigo Association), and an unidentified employee of the program. (Courtesy of Bob and Rachel Torres.)

The original Mr. Amigo Association was organized to promote friendship between the United States and Mexico. This 1965 photograph includes members of the organizing committee. From left to right are Eleanor Kerconnell, Bill Rudd (founder of the Mr. Amigo Association), Laverne and Chano Hinojosa, Blanche Beechie, Bat Corrigan (the first Mr. Amigo president), Rachel Torres (a Brownsville Chamber of Commerce officer), and Charlie Beechie. (Courtesy of Bob and Rachel Torres.)

In October 1964, Miguel Aleman, president of Mexico from 1946 to 1952, received the first Mr. Amigo award, setting the standard for future recipients. Aleman was a strong proponent of industrialization and Mexican tourism, spearheading efforts to establish Acapulco as an international resort. (Courtesy of Bob and Rachel Torres.)

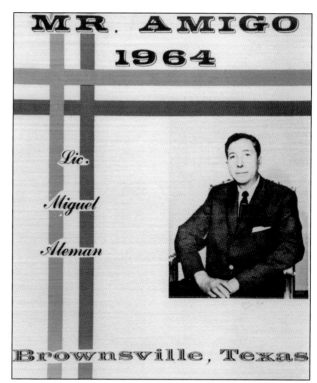

In 1965, comic and movie actor Mario Moreno/Cantinflas became the second Mr. Amigo. His many screen roles as policemen, businessmen, and bullfighters made him the most beloved and successful comedic actor in Mexican history. His major American movie was *Around the World in Eighty Days*. Cantinflas (center) is seen here with Brownsville businessman Tony Carnesi (left) and rancher Martín "Tino" García. (Courtesy of Bob and Rachel Torres.)

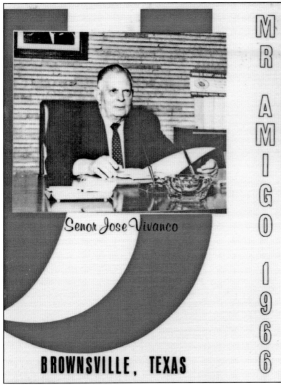

MR AMIGO 1966

Señor Jose Vivanco

BROWNSVILLE, TEXAS

In 1966, José Vivanco became the third Mr. Amigo. Vivanco was a civic leader, a former governor of the Mexican state of Nuevo Leon, and a previous cabinet advisor to Mexican president Gustavo Díaz Ordaz. As director general of the *Programa Nacional Fronterizo* (National Border Program), Vivanco led government efforts to modernize and beautify areas along the U.S.–Mexico border. (Courtesy of Bob and Rachel Torres.)

Bob and Rachel Torres, accompanied by other members of the Mr. Amigo Association, spent an evening in Mexico City at the home of Raúl Velasco, Mr. Amigo 1973, listening to some of Mexico's top entertainers. Among them were Los Hermanos Zaizar (the Zaizar Brothers), nationally known singers and composers. The Velascos were most gracious hosts. (Courtesy of Bob and Rachel Torres.)

In 1976, prolific composer Armando Manzanero (right) was selected as Mr. Amigo. Manzanero is pictured with previous recipients Raúl Velasco (left, 1973) and Pedro Vargas (center, 1974) at the Benjamin Franklin Library Annex of the U.S. Embassy in Mexico City. The occasion was the official announcement of Manzanero's selection. (Courtesy of Bob and Rachel Torres.)

In 1975, longtime entertainer and movie star Tito Guizar was selected as Mr. Amigo. A veteran of more than 40 motion pictures in Hollywood, Mexico, and Argentina, Guizar costarred with Rita Hayworth, Bing Crosby, and Bob Hope, and appeared on the Ed Sullivan, Jackie Gleason, and Johnny Carson Shows. He was the first Mexican entertainer to be invited to the White House. (Courtesy of Bob and Rachel Torres.)

Tito Guizar

1975 MR. AMIGO

BROWNSVILLE, TEXAS

The 1976 Mr. Amigo was elite Mexican composer Armando Manzanero. A full-blooded Mayan from the state of Yucatán, his songs have been translated and performed in the languages of many countries. English versions of "It's Impossible" and "Yesterday I Heard the Rain" were made popular by Perry Como and Tony Bennett. His music bridged cultural boundaries throughout the world. (Courtesy of Bob and Rachel Torres.)

The 1977 Mr. Amigo, Vicente Fernandez, is the consummate entertainer, performing live, in the recording studio, and in motion pictures. His *ranchero* style has made him a musical icon with hits such as "Volver Volver" (Return Return) and "Tu Camino y el Mío" (Your Road and Mine). He performed at the Amigoland Mall in Brownsville before 15,000 adoring fans. (Courtesy of Bob and Rachel Torres.)

In 1979, *Lola la Grande* (Lola, the Great One) was the first female Mr. Amigo selection. Born María Lucila Beltrán Ruiz in the state of Sinaloa, Lola Beltrán emerged from a singer in a church choir to be *La Reina de la Canción Ranchera* (the Queen of Ranchera Song). (Courtesy of Bob and Rachel Torres.)

Below, from left to right, Rachel Torres, the first female president of Mr. Amigo; Lola Beltrán, the first female Mr. Amigo; Steve Bosio, a member of the Brownsville Chamber of Commerce; and Bob Torres, a member of the Mr. Amigo Association; are pictured as Beltrán arrived in Matamoros. (Courtesy of Bob and Rachel Torres.)

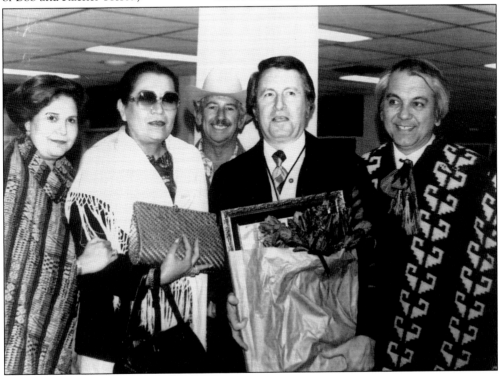

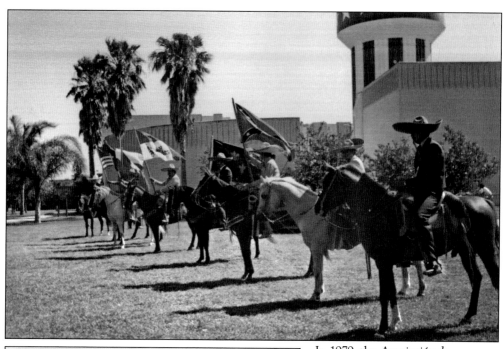

In 1979, the *Asociación de los Charros* was founded by Jorge Hinojosa, Juan de Dios, Pedro Gonzales, and Ramon García, pictured above from left to right. They are wearing traditional *trajes charros de gala* (gala charro costumes). The *asociación* organizes Mexican rodeos and donates the funds to the Jerry Lewis Telethon for Muscular Dystrophy. This 1986 photograph was taken at the University of Texas at Brownsville. (Courtesy of Melissa Ortiz.)

The 1983 Mr. Amigo, Juan Gabriel (Alberto Aguilera Valdez) began his singing career at age six in his hometown of Ciudad Juarez, Chihuahua. His father, a tenant farmer, inspired him by writing and singing his own songs. Gabriel is one of the premier composers, performers, and recording artists of Mexico. Many other singers, including four Mr. Amigos, have interpreted and recorded his songs. (Courtesy of Bob and Rachel Torres.)

Discovered by previous Mr. Amigo Pedro Vargas, José José was born José Romulo Sosa Ortiz. His stage name combined his first name and that of his father. He was discovered in Mexico City while performing with the trio *Los Peg*. In 1970, he received a Gold Record Award in Hollywood. For three decades, he has remained one of the most popular entertainers in Mexico. (Courtesy of Bob and Rachel Torres.)

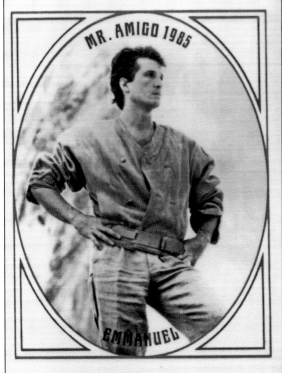

The 1985 Mr. Amigo honoree, Emmanuel, was the son of a famous bullfighter and classical flamenco dancer. He pursued bullfighting briefly until he was severely gored. Emmanuel then became a phenomenally successful recording artist and entertainer. Also sponsored by Pedro Vargas, the young singer received the prestigious El Heraldo (the Herald) Award in 1976 and later became an internationally respected artist. (Courtesy of Bob and Rachel Torres.)

"BROWNSVILLE, BROWNSVILLE"

PHOTO - RUDDIE LIZARD

Lucia MENDEZ

MR. AMIGO 1987

In 1987, the Mr. Amigo Award was given to model, dancer, actress, and recording star Lucía Mendez. In 1972, she became nationally known when an influential newspaper described her as the woman with the "most beautiful face" in Mexico. After a sensational career as a model posing in French, Latin American, and American magazines, she began acting with established movie stars such as Anthony Quinn and Cantinflas. Mendez also acted in some of the most successful soap operas in the United States and Latin America, including *Viviana* and *Tu o Nadie* (You or No One). (Both, courtesy of Bob and Rachel Torres.)

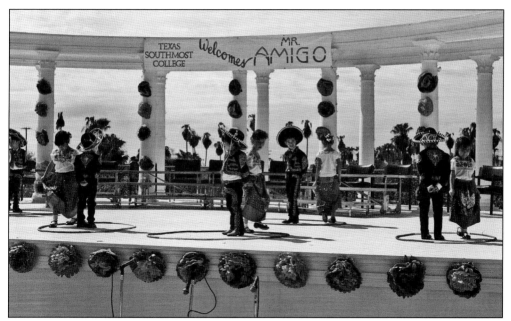

At the University of Texas at Brownsville campus, Brownsville school children perform for Mr. Amigo before he performs for them and their families. The boys are dressed as traditional charros and the girls are dressed as chinas poblanas. It is a campus tradition to have local dancers and musicians showcase their talents for the Mr. Amigo recipients. (Courtesy of UTB/TSC Media Services.)

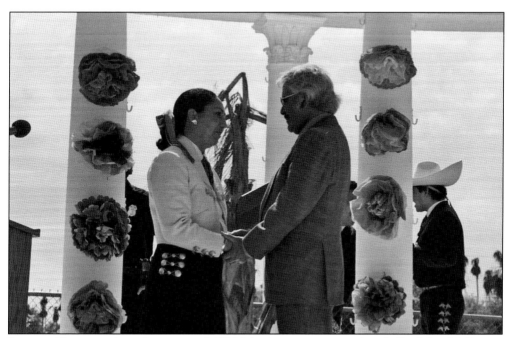

Ernesto Alonzo, author, director, and 1989 Mr. Amigo, is pictured with Dr. Juliet V. García, president of the University of Texas at Brownsville, at the Marion Hendrick Smith Memorial Amphitheater. The campus, located on the site of historic Fort Brown, borders the Río Grande and is next to the Gateway International Bridge. (Courtesy of UTB/TSC Media Services.)

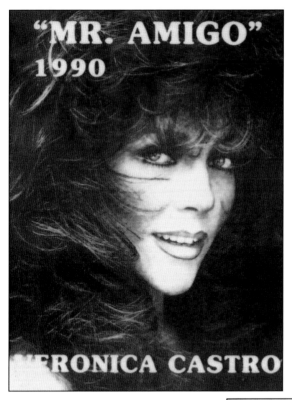

"MR. AMIGO" 1990

VERONICA CASTRO

The 27th Mr. Amigo recipient was television actress and recording artist Veronica Castro. When her mother became a single parent, Castro, then just a teenager, took the responsibility of caring for her younger brothers and sister. Castro first appeared on the *"Loco" Valdes Show*, promoting toys and dancing. Today she is known throughout the United States, Latin America, and Europe. (Courtesy of Bob and Rachel Torres.)

The 30th anniversary Mr. Amigo honoree was Chihuahua native Lucha Villa in 1993. Villa began her film career in the 1963 movie *El Gallo de Oro* (*The Gold Rooster*) and has amassed 45 motion pictures and 50 hit records. Her raspy *ranchera* voice has wowed audiences worldwide, and today she continues to perform the mariachi and bolero songs that have made her famous. (Courtesy of Bob and Rachel Torres.)

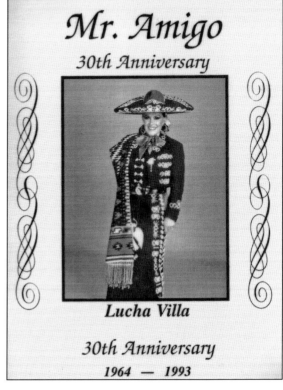

Mr. Amigo

30th Anniversary

Lucha Villa

30th Anniversary

1964 — 1993

Many Brownsville school teachers teach about and participate in Charro Days. A Mrs. Contreras, a second grade teacher at Clearwater Elementary, is pictured with Kayla Abrego (left) and her sister Patricia Abrego (right). They danced the *fandango* at the local stadium and participated in the Children's Parade in downtown Brownsville. (Courtesy of Kalya Abrego.)

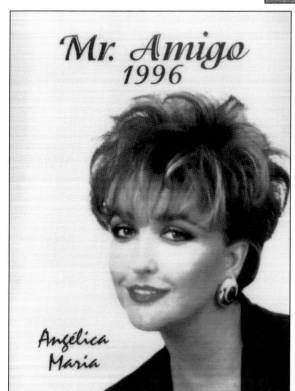

Angélica María, known as "*La Novia*" (the Sweetheart) of Mexico, was the 1997 Mr. Amigo. For more than 40 years, she has sung, acted, and recorded. At the age of nine, she received Mexico's best child actress award for the movie *Mi Esposa y Yo* (My Wife and I). Her résumé includes over 40 television dramas, 16 television soap operas, and 56 motion pictures. (Courtesy of Bob and Rachel Torres.)

Mr. Amigo 1996, Angélica María (left), is pictured with Bob and Rachel Torres, founding and longtime members of the Mr. Amigo Association. During the three days of Mr. Amigo activities at the Charro Days festival, the honoree is accompanied to the various functions by Mr. Amigo members. (Courtesy of Bob and Rachel Torres.)

This 1996 photograph of grandmother Ninfa Lopez and grandchildren Ramiro Garza III and Nancy Garza was taken as they were readying to attend one of the Mr. Amigo events. Nancy is wearing a china poblana dress made by her grandmother. To Nancy, now a college student, this photograph has a special meaning because it represents family across generations. (Courtesy of Nancy Garza.)

In 1999, the Mr. Amigo honoree was legendary stage, television, and film actress Silvia Pinal. At age 14, she starred in *A Mid Summer's Night Dream* at the Bellas Artes Theatre in Mexico City. Pinal has more than 100 feature films to her credit and the long-running television series *Mujer, Casos de la Vida Real* (Woman, Cases in the Real Life). (Courtesy of Bob and Rachel Torres.)

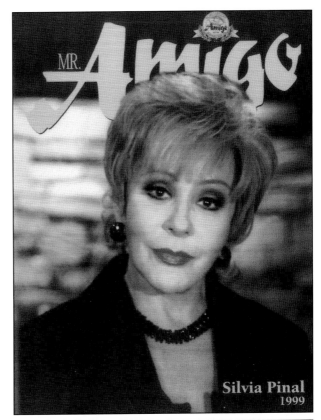

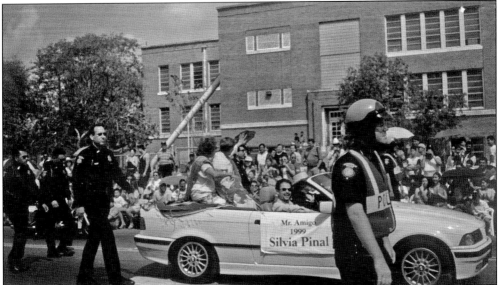

The 1999 Mr. Amigo, Silvia Pinal, was the only recipient not to attend the Mr. Amigo festivities. Her daughters, Silvia Pasquel (right) and Alejandra Guzman, represented their mother. One of the Mr. Amigo traditions is that the honoree be part of the Friday night illuminated parade and the Saturday International Parade in downtown Brownsville. They are pictured waving to the spectators. (Courtesy of Daniela Rodriguez.)

Many children participate in the Charro Days festivities at an early age. Steven Escamilla, pictured in a traditional peon costume, was only one year old in this 1999 Charro Days photograph. He is waiting to see Mr. Amigo. It was his first Charro Days, and he has attended the event every year since. (Courtesy of Christy Escamilla.)

The 2003 Mr. Amigo honoree was internationally acclaimed singer/actress and Matamoros, Tamaulipas, native Dulce (Bertha Elisea Noeggerath). Promoted early in her career by former Mr. Amigo José José, she was soon performing at *Pabellón Real* (the Royal Pavilion) in Spain and along with Donna Summer at Japan's Music Festival. Her first gold record was entitled *Heridas* (Wounds) and was the first of many hits. (Courtesy of Bob and Rachel Torres.)

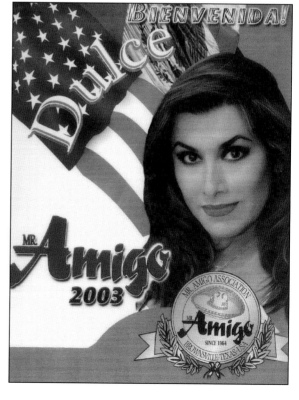

Sergio Bustamante, Mr. Amigo 2005, is the most famous sculptor in Mexico. Of Chinese and indigenous ancestry, Bustamante's artistic influences are original and inspirational. His training in Guadalajara, Mexico, and Amsterdam, Holland, prepared him to become a world-renowned artist whose media include bronze, wood, and ceramics. Today his works are presented in exclusive exhibits throughout the world. (Courtesy of Bob and Rachel Torres.)

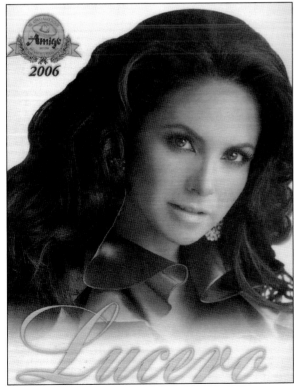

Lucero, an actress and recording star, was designated as the 2006 Mr. Amigo. She began acting at the age of 10 and soon garnered her first leading role in the children's television series *Chiquilladas* (Youngsters). Her 1993 self-titled *Lucero* album became a best seller. In 2006, Lucero received a Best Actress Award for her performance in the popular soap opera *Alborada*. (Courtesy of Bob and Raquel Torres.)

This 2007 photograph is of a six-month-old baby already dressed in a china poblana for her first Charro Days. Her mother, UTB/TSC student Irma Valle, said that she wants to maintain the border traditions and to teach her children their culture. She also believes that her children should grow up speaking both English and Spanish, and that they, in turn, will be bicultural and bilingual. (Courtesy of Irma Valle.)

Below, baby Jiselle Galvan, daughter of UTB/TSC student Claudia Galvan, is pictured with 2008 Mr. Amigo Angélica Vale. Vale is known for her portrayal of "Betty *la Fea,*" the original Mexican version of the popular American television series *Ugly Betty.* For Jiselle, this was the first of many future Charro Days celebrations. (Courtesy of Claudia Galvan.)

The 2009 Mr. Amigo honoree is Jose Sulaiman, a longtime business administrator and manufacturer. In 1975, he became president of the World Boxing Council, which includes 161 member countries. In 1986, he became president of the Mexican Council and Museum for Professional Sports. Sulaiman has been credited with humanizing the sport of boxing more than any previous individual in its history. (Courtesy of Bob and Rachel Torres.)

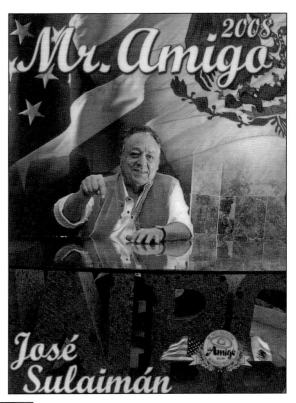

The little girl with the big smile is Miranda Rose Escamilla. On February 28, 2009, she attended the Mr. Amigo celebration held at the local university. Miranda, a primary school student, is dressed in a Mexican peasant blouse accessorized with colorful necklaces and hair bow. She is the daughter of UTB/TSC student Christy Escamilla. (Courtesy of Sandra Flores.)

José Manuel Mijares (fifth from left) was selected as Mr. Amigo of 1995. Heartthrob handsome as well as an accomplished musician and singer, Mijares would marry another Mr. Amigo, Lucero, in 1997. In this photograph, he appears with the president of the Mr. Amigo Association, Ygnacio "Nacho" Garza (wearing tie), former, and probably tallest, mayor of Brownsville. (Courtesy of Clemente Rendon.)

Six

THE SOMBRERO FESTIVAL

The Sombrero Festival began in 1986 and was the brainchild of local businessman Danny Loff. His goals for the new festival were to provide family activities and entertainment, and to revitalize activities and competitions once popular during earlier Charro Days festivities. Included among these are the beard and biggest whiskers competition, the *frijolympics* (bean cook-off), the jalapeño eating contest, and the 10-mile run. More recent additions are the waiters' race and the tug-of-war contests. Trophies and ribbons are awarded to the winners, and both participants and spectators are thoroughly entertained.

One element in the success of Sombrero Fest is the generosity of hundreds of volunteers who make this event possible. They contribute during all phases, from planning to clean up. Not only does the festival provide family entertainment, but its organizers donate some of its profits to charitable organizations and to Brownsville educational facilities such as museums and the public library.

From a one-day festival with a few events and food booths, Sombrero Fest, as it is popularly known, is now a three-day festival with many activities and dozens of booths. Each day of the festival concludes with a music concert performed by Tejano, *conjunto* (musical ensemble, including accordion), or country-and-western recording artists. The Sombrero Festival, although not an original component of the Charro Days festival, has become a welcomed addition and increases in popularity every year.

The Sombrero Festival was the brainchild of Danny Loff, a local businessman and Brownsville native. Inaugurated in 1986, the festival was created to revitalize the family activities and entertainment of earlier Charro Days festivities. Loff is pictured here performing a *grito* (yell) in a traditional charro costume in front of a marimba ensemble. (Courtesy of Danny Loff.)

Community volunteers have always been a part of the success of Sombrero Fest. In this 1991 photograph, Jack Loff, assistant professor in the Health and Human Performance Department at the University of Texas at Brownsville and founding member of the Sombrero Fest Association, is busy placing a Mexican flag at the event site. (Courtesy of Sammy Herrera.)

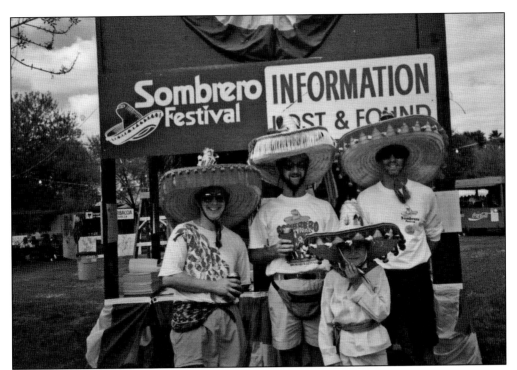

A week before Sombrero Fest begins, signs announcing the festival and its sponsors are placed at the future site of the event. Soon after, the area is fenced, and preparations begin, including the building of the stages and food booths. This photograph of festival volunteers was taken at Washington Park, the location for many Sombrero Fests. (Courtesy of Danny Loff.)

In this 1998 photograph, Sandra Herrera, president of the Sombrero Festival, serves as the official greeter. This Porter High School science teacher has volunteered in various capacities at the festival for several years. She is dressed in a traditional china poblana Mexican costume while she prepares to welcome people to the event. (Courtesy of Sammy Herrera.)

Washington Park is the 5-acre site of the annual three-day Sombrero Festival. At the center of the park is a beautiful illuminated fountain, built in 1927. Many of the festival's events take place here. Next to the park is one of Brownsville's oldest elementary schools, Annie S. Putegnat. (Courtesy of Alfonso "Tiny" Barrientes.)

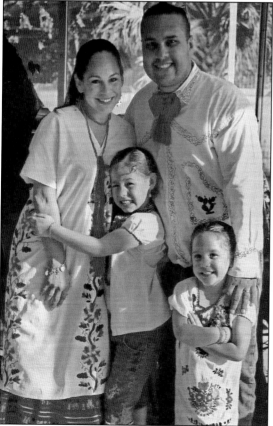

Sombrero Fest is typically a family affair. In this 2008 photograph, Eduardo and María Martinez and their two children, all in Mexican costumes, will soon leave for the festival. As educators, Eduardo and María know the importance of preserving and passing on Charro Days traditions, so both serve as community volunteers for various Charro Days activities. (Courtesy of Alfonso "Tiny" Barrientes.)

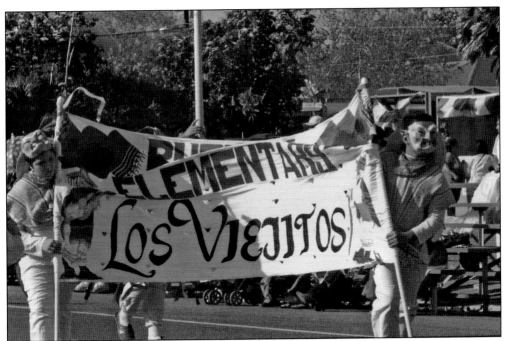

The Sombrero Festival celebrates both border and Mexican traditions. In this picture, students perform *La Danza de lo Viejitos* (Dance of the Old Men), a Michoacán pre-Columbian dance that honors elders. The young male dancers, attired in Purepecha indigenous costumes, which include a mask, hat, and *morral* (knapsack), perform to show their respect and appreciation for their elders. (Courtesy of Juan M. Cantu.)

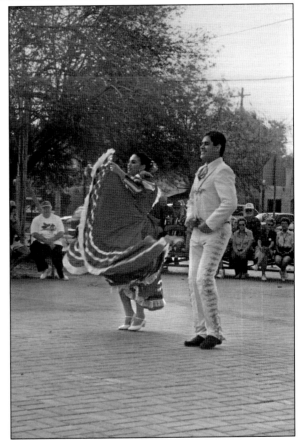

Among the numerous performers at Sombrero Fest is the internationally known Folklórico Tizatlán. This dance group, organized by Dr. Zelma Mata, associate professor in the Health and Human Performance Department at the University of Texas at Brownsville, has performed at many venues in the United States and Mexico. In this photograph, two students perform one of the traditional Mexican dances. (Courtesy of Danny Loff.)

Many volunteers work throughout the three-day Sombrero Festival, building up an appetite. Rick Flores, a volunteer, is pictured in this 2008 photograph grilling fajitas (beef skirts) for the other volunteers. Fajitas, originally a border delicacy, have become popular throughout much of the American Southwest in homes and restaurants. (Courtesy of Alfonso "Tiny" Barrientes.)

Alfonso "Tiny" Barrientes (right) and Francisco "Poncho" Gomez (left), both former presidents of Sombrero Fest, are preparing tortillas and tacos in 2007 for the dozens of volunteers who work long hours at the event. Their work ethic is indicative of the dedication of the Sombrero Festival members to ensure its success. (Courtesy of Alfonso "Tiny" Barrientes.)

One of the interesting sites at the Sombrero Fest food booths is *la calavera* (the skull). For 22 years, Sombrero Fest board member Alfonso "Tiny" Barrientes has displayed the skeleton attired in a Charro Day costume next to the *gordita* (thick corn tortilla) booth. *Calaveras* are often associated with *El Día de los Muertos* (the Day of the Dead) celebration in Mexico and the American Southwest in early November. (Courtesy of Alfonso "Tiny" Barrientes.)

Pictured are contestants competing in the jalapeño-eating contest. The objective in this event is to eat the most jalapeños in 10 minutes. Trophies and money are awarded to winners in the male and female categories. Participants must be at least 18 years old. One year, a male contestant ate 87 jalapeños for the all-time record. (Courtesy of Sammy Herrera.)

One of the more popular competitions at Sombrero Fest during the 1990s was the *grito* contests for adults and children. Pictured is Mariano "Bean" Ayala, the master of ceremonies and executive director of the Brownsville Convention and Visitors Bureau, encouraging an elementary school student. Males and females compete in separate categories, and the winners receive trophies. (Courtesy of Sammy Herrera.)

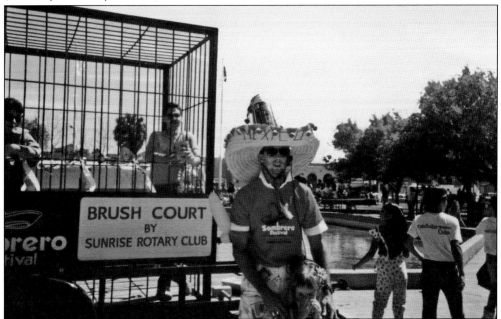

The Beard Contest was begun during the first Charro Days festival in 1938. The Brush Court enforced the rule that any adult male without a beard be thrown in jail and required to pay a fine to leave. The "fine" was a $20 donation to a nonprofit organization such as the Sunrise Rotary Club. In this picture, two individuals have been placed in "jail" until their "fines" are paid. (Courtesy of Danny Loff.)

The Beard Contest, begun in the mid-1990s, remains a crowd favorite at Sombrero Fest. Categories in this competition include biggest whiskers, best groomed beard, and ugliest beard. Judges are all women, and trophies are awarded to the winners. Pictured along with one of the judges is multiple-year winner Steven Rucker. (Courtesy of Danny Loff.)

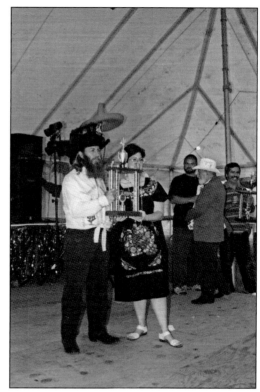

The *frijolympics* (bean cook-off) is the longest-running contest at the Sombrero Festival. Contestants decorate their booths and start cooking early in the morning. Judges are selected by the Sombrero Fest Association, and the cook with the winning entry receives $1,000 and a trophy. Visitors to the booths may sample the various *frijoles a la charra* recipes to compare taste and predict possible winners. (Courtesy of Sammy Herrera.)

A popular South Texas dish is the white flour tortilla taco. Pictured is Port of Brownsville official and Sombrero Fest volunteer George Gavito holding what appears to be a tortilla on steroids, approximately 20 inches in circumference. This tasty morsel and others will soon be devoured in the Taco Eating Contest, a favorite event. (Courtesy of Alfonso "Tiny" Barrientes.)

The Taco Eating Contest attracts many contestants for various reasons. Some like the heat of the competition. Some like the heat and the taste of the tortillas. For whatever the reason, the contest is well attended, with both participants and spectators enjoying the timed event. Winners receive trophies, and all participants receive complimentary T-shirts. (Courtesy of Alfonso "Tiny" Barrientes.)

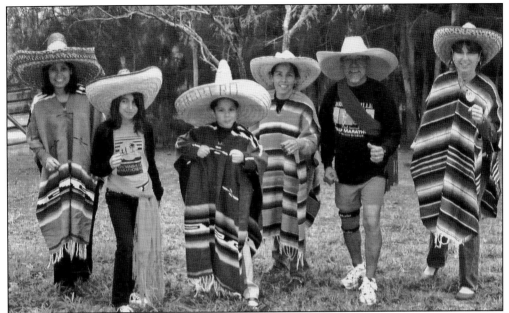

Running Club members pose before the 10K run associated with the Sombrero Festival in 2009. More than 1,000 runners participated and raised funds for four $1,000 scholarships. An important goal of the event is to involve area students. Pictured from left to right are Norma Molina, Riley Shoemaucker, Noah Garza, Yoli Barrientes, Alfonso "Tiny" Barrientes, and Marie Shoemaucker. (Courtesy of Alfonso "Tiny" Barrientes.)

This is a 1998 photograph of the Hat Relay, an event begun for its namesake sombrero or hat. Teams consisting of two males and two females must run an obstacle course around the fountain while maintaining the hats on their heads. Winning teams receive trophies and the prestige of winning the relay. (Courtesy of Sammy Herrera.)

The Waiters Race, begun in 1986, is a relay competition involving waiters and waitresses from area restaurants. Each participant carries a can-filled tray through an obstacle course that includes tires and other hazards. The coed team with the best time receives trophies and bragging rights for one year. (Courtesy of Sammy Herrera.)

The tug-of-war competition has been part of Sombrero Fest for more than 20 years. Initiated by Alfonso "Tiny" Barrientes, this popular event attracts local as well as out-of-town participants who vie for prizes such as T-shirts and trophies. The 10-member teams must include at least four women. (Courtesy of Danny Loff.)

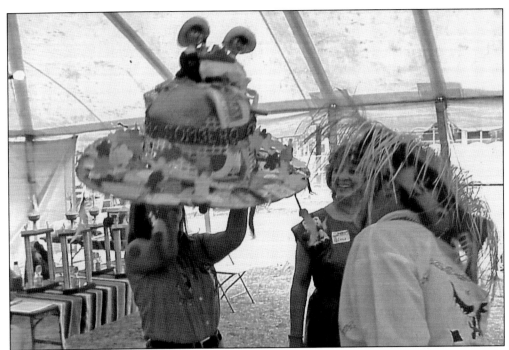

One of the liveliest and most colorful competitions at Sombrero Fest is the Sombrero or Hat Contest. Begun in the mid-1990s, this event brings together many people who think that their hats are the most unique and the most worthy of receiving prizes and trophies. Judging is held in a large tent called the Bird's Nest. Pictured are two contestants and a judge. (Courtesy of Sammy Herrera.)

For the last 15 years, Sombrero Fest has hosted a Children's Costume Contest. Categories included best costume for boy and best costume for girl. Members of the Pan American Roundtable, recognized experts in Mexican costume, are the judges. Pictured are a young boy in a traditional charro costume and a girl in an Aztec costume. (Courtesy of Sammy Herrera.)

Because children often require undivided attention, Sombrero Fest includes the *Para Niño* (For the Child) event. Supervised activities at this venue include the hula hoop, free throw, pickle eating, and *grito* contests. In this picture, from left to right, Charlie Alaniz, Tommy Bermudez, and Sammy Herrera supervise the contest while giving parents some adult time at the festival. (Courtesy of Danny Loff.)

Six-year-old Keli Rae Loff is pictured here petting a small chick at the 1989 Sombrero Festival. Keli, then a Gonzales Elementary School student and daughter of Sombrero Fest founder Danny and Suzanne Loff, has attended the event since she was a baby. Sombrero Fest provides activities for children, including a petting zoo and face painting. (Courtesy of Danny Loff.)

"Little Joe" Hernandez, who has performed on five different occasions at Sombrero Fest, has been an entertainer and recording artist for almost four decades. In the 1970s, he was at the forefront of *La Onda Chicana,* or the "Chicano Genre," which combined *ranchero, conjunto,* polkas, and jazz. His signature song "*Las Nubes*" (The Clouds) became an anthem for the United Farm Workers movement during the late 1960s. (Courtesy of Alfonso "Tiny" Barrientes.)

In 2008, the Saturday night Sombrero Fest headliner was Emilio Navaira, a San Antonio native and award-winning Tejano singer. Navaira and his group Río have performed for 20 years to sold-out audiences in the United States and Mexico. He performs in Spanish and English, and has also recorded a country album entitled *Life is Good.* (Courtesy of Alfonso "Tiny" Barrientes.)

One of the more colorful Tejano bands to perform at Sombrero Fest is El Circo Tejano. Dressed in their zebra outfits, sunglasses, and brightly colored feathered sombreros, they delight the crowds with their *conjunto* (guitar/accordion ensemble) and Tejano tunes. These versatile musicians play a variety of instruments, including strings, saxophone, and accordion. (Courtesy of Alfonso "Tiny" Barrientes.)

Sombrero Fest board member and officer Tommy Bermudez (left) is pictured with award-winning magician and comedian "Happy" (Efraín Guerrero). Considered one of the top Latino comedians in the country, Happy has performed in concerts throughout the United States, Mexico, and Puerto Rico. Recently, he performed at the Improv in Harrah's Hotel and Casino in Las Vegas to a full house for 12 consecutive nights. (Courtesy of Alfonso "Tiny" Barrientes.)

Angelica Vale, the 2008 Mr. Amigo, attended and sang at various Sombrero Fest events, including one that featured Brownsville elementary school dancers. Vale, a multitalented performer, is best known for her comedic role in the Mexican soap opera *La fea más bella*, which has become the extremely popular *Ugly Betty* in American television. (Courtesy of Alfonso "Tiny" Barrientes.)

Traditionally, the Mr. Amigo honoree attends Sombrero Fest and is recognized at a luncheon provided by the Mr. Amigo Association. Here Mr. Amigo 2007, Lucero (left), and former Brownsville Independent School District administrator and Mr. Amigo president Sylvia Perez (right) are pictured at the luncheon. Lucero, a Mexican recording artist and television actress, is dressed in a traditional charra costume. (Courtesy of Alfonso "Tiny" Barrientes.)

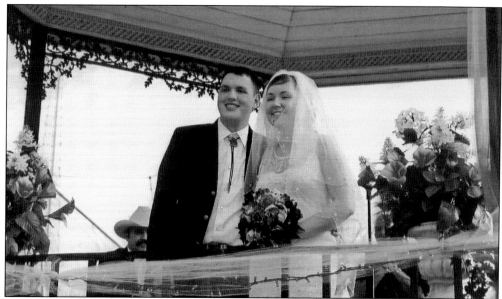

Sombrero Fest is an event for all occasions. In this 2008 photograph, Jacob and Selrah Rosas have just been married. They are the first and only couple to be married during the festival. The Sombrero Fest tradition was so important to them and their parents that they decided to share their wedding vows with the Brownsville community. (Courtesy of Alfonso "Tiny" Barrientes.)

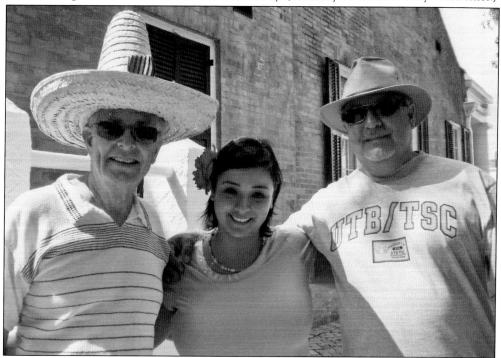

Last, and probably least, is this image of the "three amigos," the coauthors of Images of America: *Charro Days in Brownsville*. Tony Knopp appears on the left in the sombrero, while Pricilla Rodriguez wears a flower in her hair. Manny Medrano sports his "cruiser" hat on the right. The setting is the courtyard of the Stillman House Museum. (Courtesy of Javier Garcia.)

Bibliography

Adams, William, and Anthony Knopp. *Brownsville: Portrait of a Border City*. Austin, TX: Eakin Press, 1997.

Aiken, Bruce. *Ballots, Bullets, and Barking Dogs*. Brownsville, TX: The Historic Brownsville Museum Association, 1996.

Amberson, Mary Margaret McAllen, James A. McAllen, and Margaret H. McAllen. *I Would Rather Sleep in Texas: A History of the Lower Rio Grande Valley and the People of the Santa Anita Land Grant*. Austin, TX: Texas State Historical Association, 2005.

Chatfield, W. H. *The Twin Cities of the Border*. New Orleans: E. P. Brandao, 1893; reprinted by the Brownsville Historical Association, 1959.

Chilton, Carl. *Fort Brown: The First Border Post*. Brownsville, TX: University of Texas at Brownsville, 2005.

Coker, Caleb. *The News from Brownsville: Helen Chapman's Letters from the Texas Military Frontier*. Austin, TX: Texas State Historical Association, 1992.

Kearney, Milo, and Anthony Knopp. *Boom and Bust: The Historical Cycles of Matamoros and Brownsville*. Austin, TX: Eakin Press, 1991.

——— and Manuel Medrano. *Medieval Culture and the Mexican American Borderlands*. College Station, TX: Texas A&M Press, 2001.

Wooldridge, Ruby, and Robert Vezzetti. *Brownsville, A Pictorial History*. Brownsville, TX: The Brownsville Historical Association, 1982.